IMAGES
*of America*

# PORT OF
# SACRAMENTO

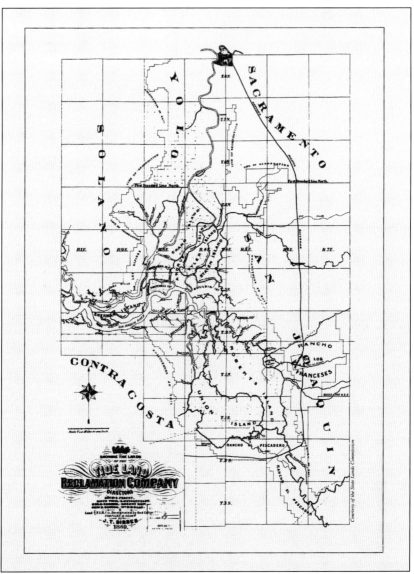

This is an 1869 Tidewater Reclamation Company map of the Sacramento–San Joaquin River Delta. Much of the early delta region was swampland. In 1861, the California State Legislature created the Board of Swamp and Overflowed Land Commission to manage reclamation projects in the delta. By the 1930s, nearly 550,000 acres on some 55 artificially made islands had been reclaimed. The deepest waterways for shipping have been both the Sacramento and San Joaquin Rivers. (Map courtesy of California Department of Water Resources-DWR.)

ON THE COVER: In this late 1960s photograph, a freighter can be seen going up the Sacramento River Deep Water Ship Canal toward the Port of Sacramento The highway on the right is State Route 84, or Jefferson Boulevard. Much of this agricultural land has been replaced by new housing developments.

IMAGES
*of America*

# PORT OF
# SACRAMENTO

West Sacramento Historical Society

ARCADIA
PUBLISHING

Published by Arcadia Publishing
Charleston, South Carolina

Printed in the United States of America

Library of Congress Catalog Card Number: 2006939084

For all general information contact Arcadia Publishing at:
Telephone 843-853-2070
Fax 843-853-0044
E-mail sales@arcadiapublishing.com
For customer service and orders:
Toll-Free 1-888-313-2665

Visit us on the Internet at www.arcadiapublishing.com

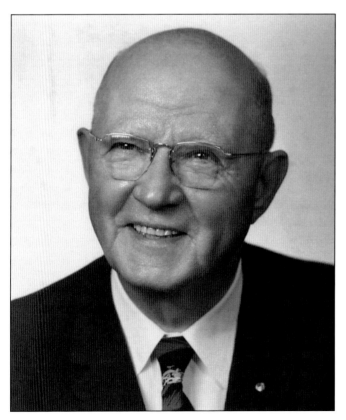

William G. Stone was known as the "Father of the Port" with over 50 years of transportation experience that included being the traffic and industrial manager of the Sacramento Chamber of Commerce for 16 years, a member of the board of directors of the National Industrial Traffic League, and the first director of the Port of Sacramento (1947–1963).

# CONTENTS

# ACKNOWLEDGMENTS

The West Sacramento Historical Society began as an organization in 1993. From its inception, members began collecting and duplicating photographs relating to East Yolo and West Sacramento. In 2005, with the help of city financial support, the historical society established the first museum in West Sacramento, and community members brought in additional photographs and artifacts. In early 2006, the city of West Sacramento took over the management of the Port of Sacramento. During the transition period, additional photographs, documents, and other historical items were added to our collection. This book was made possible with the transfer of port photographs and port-related documents to the West Sacramento Historical Society from the City of West Sacramento. Unless otherwise noted, the images in this book came from the Port of Sacramento Collection at the West Sacramento Historical Society.

The society had previously produced a book on the history of West Sacramento through Arcadia Publishing and considered this just another challenge. Through this new acquisition, we acquired a plethora of information, including photographs and publications that recorded the entire history of the port. The challenge was this: How much historical information could we fit into a pictorial history book? This volume is the result. In addition, we thank the port administration and the International Longshore and Warehouse Union (ILWU Local 17) for making the Port of Sacramento a highly respected port in California.

To provide technical review and proofing, we were fortunate to have the current port manager, Mike Luken, and port engineer Thomas Scheeler. Their expertise was invaluable in capturing the importance of one of California's two inland ports (see map on page 8), with the other being the Port of Stockton.

Others contributing to the book were Jeri Hughes Wingfield (research, text, and editing), Louisa R. Vessell and Diana Vriend (proofing), and Thom Lewis (scanning, research, and layout editing).

Finally we would like to acknowledge all those responsible for providing photographs: the port staff, the California section of the California State Library, Yolo County Archives, the *Sacramento Bee*, Cartwright Aerials, William G. Stone, Bryan Turner, the California Department of Water Resources, the U.S. Army Corps of Engineers, and the City of West Sacramento.

Any errors in this book are unintentional. If you have evidence of historical discrepancies, please do not hesitate to bring them to the attention of the West Sacramento Historical Society.

—Book Committee,
West Sacramento Historical Society, 2006

# INTRODUCTION

The many books and articles used to document the history of the Port of Sacramento all agree that the idea of a deepwater port in the Sacramento area was conceived early in the 20th century by agricultural and other businesses interested in accessing broader U.S. and international markets. The port's dedication booklet states that the first effort to bring deep-sea shipping to Sacramento was made in 1911, when the state legislature authorized a study of the feasibility of navigation of the Sacramento River by deep-draft vessels.

Another publication, the 1993 Port Strategic Plan states, "In 1916 the Sacramento Chamber of Commerce asked the State of California to make a survey for a river channel to accommodate freighters." Gov. Hiram Johnson then directed state engineers to investigate and survey a feasible ship-canal route between Sacramento and the delta deepwater. In that same month, an advisory board to the State of California approved the expenditure of $7,000 to begin the work. Half of this cost, which was to be paid by the chamber of commerce of the City of Sacramento, was deposited with the department of engineering within a few days. The initial report by Major Norboe for a possible canal route and deepening project was followed by a ceremonial event on December 5, 1916, at Southside Park (Sacramento), and it included Governor Johnson driving the first survey stake. The ceremony was to mark the location of the Port of Sacramento.

The preliminary canal survey ran from the San Joaquin River, near Twitchell Island, up to Walnut Grove along the Sacramento River. The ship-canal survey began under the direction of assistant state engineer Paul Norboe. However, shortly afterward, the country became engaged in World War I, and work on the port project stopped. It remained dormant until 1922, when the study resumed. The quick action at the beginning of this project indicates that it was a very popular idea, yet no action was taken until 1925, when another civil engineer C. E. Grunsky proposed alternative ways to create a ship channel. One of these was adopted and finally became the port's deepwater channel.

Because constructing and maintaining navigational waterways has historically been the responsibility of the federal government and because the channel would involve foreign trade, the Army Corps of Engineers undertook the project at the request of the U.S. Congress in 1945.

Back in the early 1900s, when the decision was made to develop a seaport 76 nautical miles from the sea, Sacramento was already a successful business and transportation hub with a busy river port a few blocks from the western terminus of the transcontinental railway. With this new link to global commerce, Sacramento hoped to become one of the great trade cities of the world.

# California Inland Ports

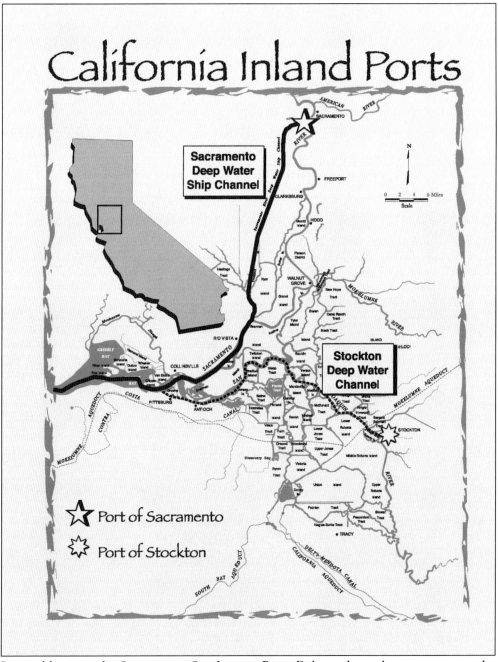

Pictured here are the Sacramento–San Joaquin River Delta and two deepwater routes, the Sacramento Deep Water Channel and the Stockton Deep Water Channel.

# One

# EARLY SACRAMENTO RIVER COMMERCE AND TRADE

Early Native Americans of California who plied the currents of the Sacramento River in tule rafts and dugouts used the river for transportation and trade long before the European settlers arrived on its shores. When Captain Sutter came up the river on the sailboat *Isabella*, he landed at the mouth of the American River on August 12, 1839. Later, in 1840, the Russians came to trade with the settlers of Sutter's Fort.

The time needed to make the trip from San Francisco by sailing vessel was usually three to four days. But when the steamboat *Stika* was built in 1847, the trip time was much reduced and schedules could be maintained. Soon the steamboat *Pioneer* joined the river traffic, which included many sailing ships. Within a few years, steamboats replaced most of the sailing fleet due to their dependability, increased cargo space, and speed. By 1908, eleven companies were operating steamboats along the Sacramento River, but by 1932, all the companies had been consolidated into one, known as River Lines, Inc., and it became the main operator of steamboats on the river. As the steamboat era of carrying cargo passed into history, it was replaced by barge transportation. Barges were used heavily in transporting grain, rice, oil, and canned goods. Until the 1950s, the Sacramento River transported gasoline and oil products from the Bay Area.

According to the *History of the Sacramento Valley* by Joseph McGowan, the Sacramento Valley has been an important agricultural center since the gold rush, when it provided wheat, hides, timber, wool, grains, fruits, and meats to the Bay Area and nearby goldfields. Between 1880 and 1903, tonnage of freight averaged from 202,000 to nearly 400,000. The San Francisco–Sacramento trade contributed about 75 percent of the total river traffic.

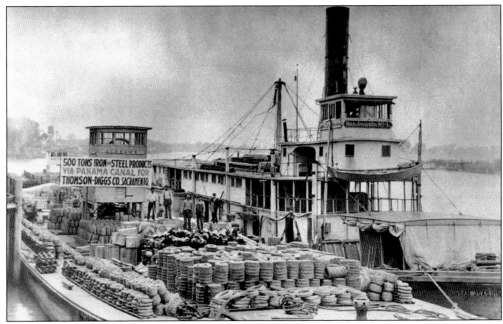

The stern-wheeler steamboat *San Joaquin*, owned by the Sacramento Transportation Company, can be seen here next to a barge loaded with supplies for the Panama Canal. The Sacramento Transportation Company owned and operated seven such steamboats during the 1900s. (Courtesy Port of Sacramento Collection, West Sacramento Historical Society and *Sacramento Bee*.)

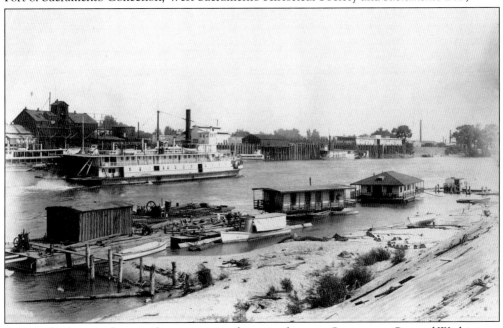

A stern-wheeler steamboat can be seen moving downriver between Sacramento City and Washington (Broderick). Most steamboats docked at Sacramento City to load or unload cargo, but steamboat repairs were done in Washington at the Sacramento Navigational Company shipyard. During this era, Washington was also the site of the first salmon-canning operation on the West Coast. (Courtesy California State Library, California History Room [CSL/CHR].)

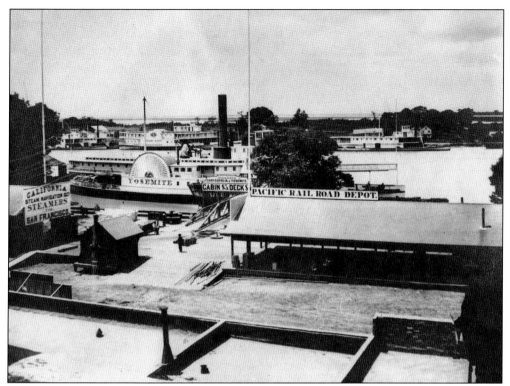

Now the site of Front Street in Old Sacramento, this riverfront photograph shows busy Sacramento City in relation to the Sacramento River. The side-wheeler steamboat *Yosemite* docked after coming up the river from the Bay Area. The *Chrysopolis* also shared this dock with the *Yosemite*, and each made round trips to the Bay Area. (Courtesy CSL/CHR.)

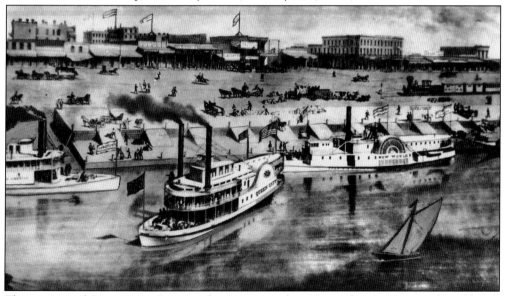

This is a typical Sacramento City riverfront scene in the 1850s and 1860s. During the gold-rush period, sailing ships and steamboats made daily trips to and from San Francisco carrying both cargo and passengers. (Courtesy CSL/CHR.)

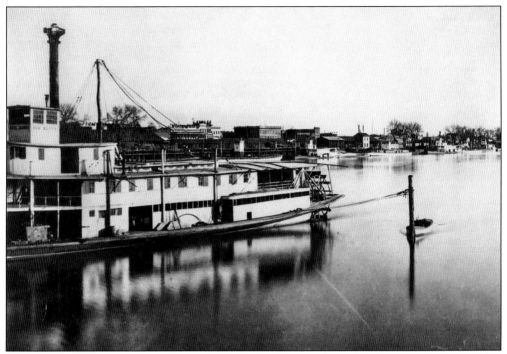

The steamboat *Red Bluff* is docked on the Yolo County side of the Sacramento River. This vessel was one of seven owned by the Sacramento Transportation Company in the early 1900s. (Courtesy CSL/CHR.)

The steamboat *Apache* is moving along the Sacramento River. The *Apache* was owned and operated by the Southern Pacific Railroad. At the beginning of the 20th century, this company carried the most freight by moving an average of 162,000 tons a year between San Francisco and Sacramento. (Courtesy CSL/CHR.)

In this photograph are the barges *Iowa* and *Alabama* and the steamboat *Red Bluff* (center). The owners of the *Red Bluff* owned 23 barges, and these may have been two from that fleet. (Courtesy CSL/CHR.)

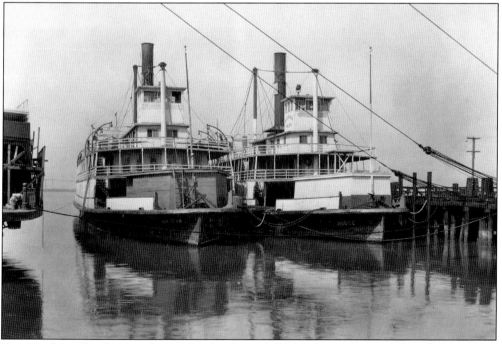

Two Southern Pacific steamboats, the *Apache* and the *Modoc*, with an unidentified vessel on left, await preparations for another voyage. This photograph may have been taken in a Bay Area shipyard. (Courtesy CSL/CHR.)

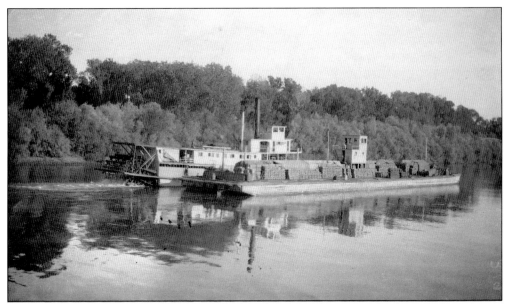

This is an unidentified stern-wheeler steamboat with barge transports cargo along the Sacramento River. In the early 1900s, San Francisco–Sacramento trade accounted for around 75 percent of the total river traffic. (Courtesy CSL/CHR.)

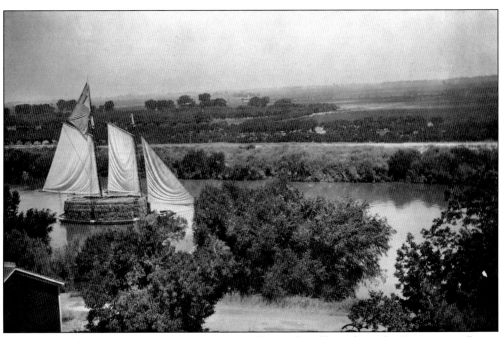

This sailing ship is transporting what appears to be stacks of hay along the Sacramento River. Most likely this cargo is from Colusa, Glenn, and other upper Sacramento Valley counties. (Courtesy CSL/CHR.)

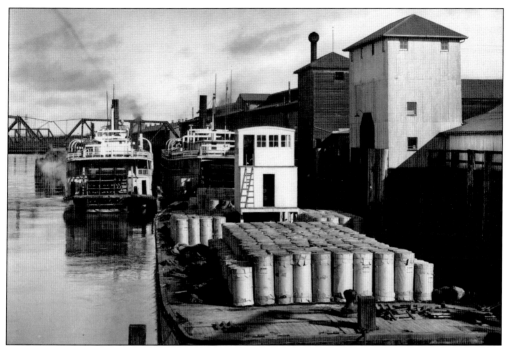

With the Sacramento Northern Electric Railroad M Street Bridge in the background, two stern-wheelers and a barge are docked on the Sacramento side of the river. The barge is carrying cargo from Pacific Mills Limited. (Courtesy CSL/CHR.)

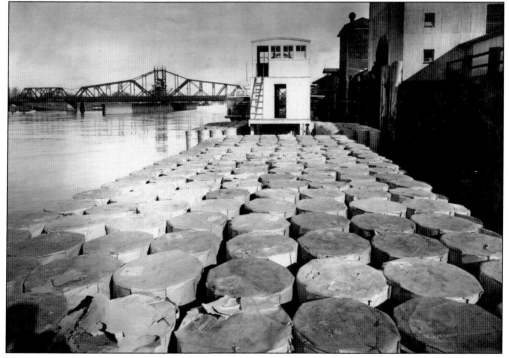

Here is another view of paper rolls from Pacific Mills Limited. This cargo is stamped for final shipment to the *Sacrament Bee* newspaper. (Courtesy CSL/CHR.)

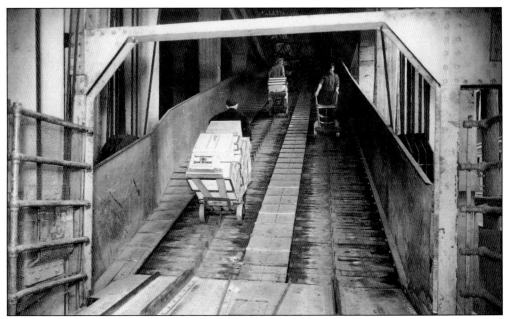

Packages of Snow Flakes crackers are being loaded from dockside to the warehouse. To ensure the handcarts don't accidentally roll back down the plank deck, steel serrated risers act has a brake system. The cart is able to roll over the extruded metal, which had a hook shape on top that would catch any runaway cart. (Courtesy CSL/CHR.)

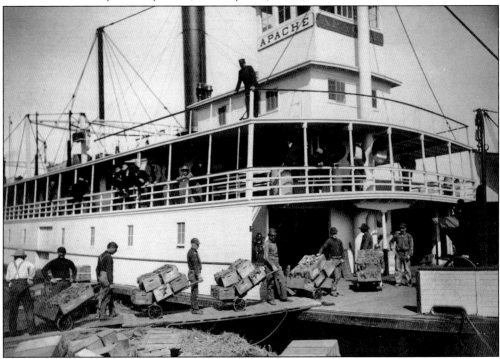

The stern-wheeler steamboat *Apache* is being loaded with crates of potatoes for shipment. Between 1901 and 1908, the amount of passenger traffic increased. Freight was carried on the lowest deck and passengers on the second and third decks. (Courtesy CSL/CHR.)

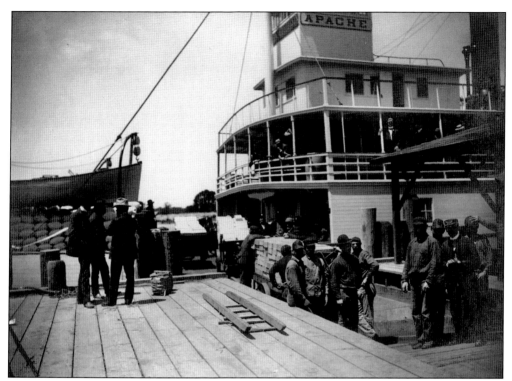

In this photograph, boxes of cherries are being loaded. While both the *Apache* and *Modoc* carried cargo and passengers, each boat could carry 500 people. (Courtesy CSL/CHR.)

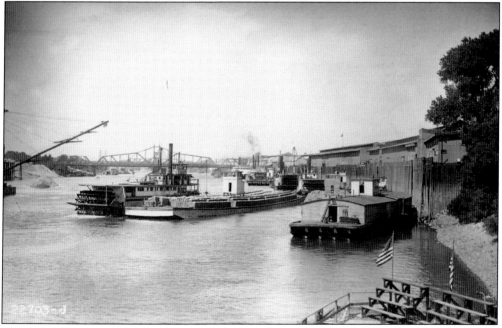

The barge *Alabama,* loaded with bags of grain, is directed to the dock by a stern-wheeler. The Sacramento Northern Electric Railroad M Street Bridge is in the background. At the right of the bridge is now the site of the Embassy Suites Hotel. (Courtesy CSL/CHR.)

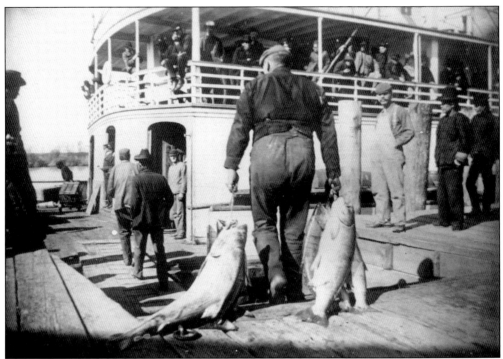

What appears to be salmon are carried onto a vessel for transport. Prior to the hydraulic methods of gold mining, the annual salmon migration up the Sacramento, Feather, and American Rivers was abundant. A decline of the salmon migration was due to silting, which reduced numbers dramatically. (Courtesy CSL/CHR.)

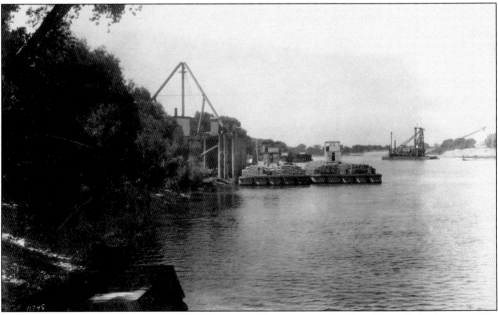

Barges loaded with bags of grain wait for transport downriver to the Bay Area. A dredge, possibly the *Yolo*, is dredging the banks of the river. A typical barge was about 230 feet long and 42 feet wide. (Courtesy CSL/CHR.)

The River Lines No. 1 covered barge is being towed upstream along the Sacramento River. In 1932, the California Transportation Company consolidated with the Sacramento Navigational Company and the Fay Line, forming River Lines, Inc. It became the main company operating steamboats on the river. (Courtesy CSL/CHR.)

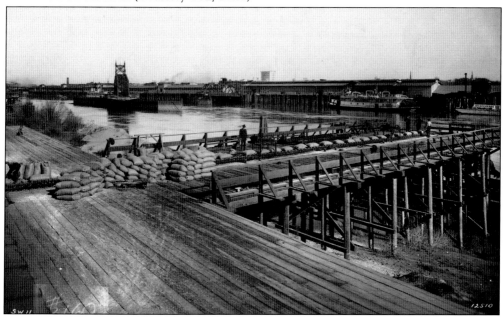

Bags of rice from the California State Rice Milling Company are stacked on the landing. Bags were placed on a conveyor system and loaded onto the barge or steamboat. Pylons in the river from this dock are still visible today. In the background, the M Street Bridge is opened to river traffic. (Courtesy CSL/CHR.)

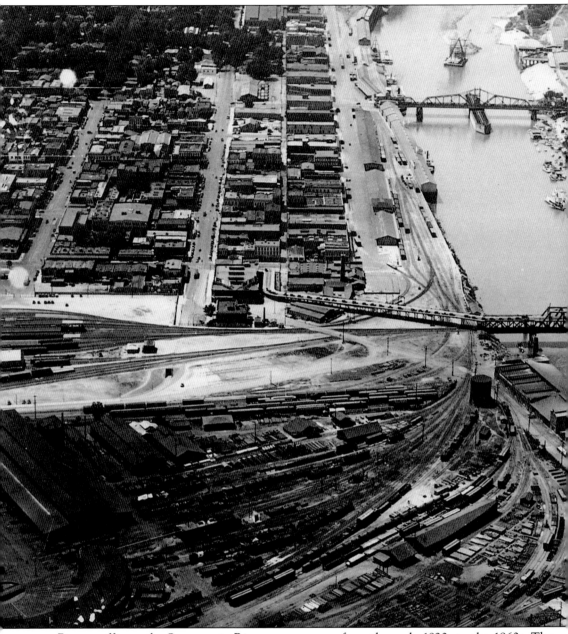

Barge traffic on the Sacramento River was common from the early 1920s to the 1960s. The Sacramento Northern Electric Railroad M Street Bridge is the background, and the Southern Pacific Railroad I Street Bridge is in the foreground. The empty barge on the right is being towed

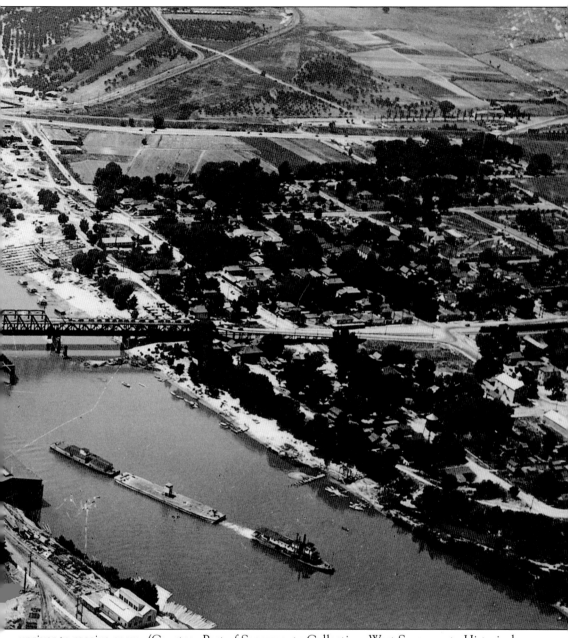

upriver to receive cargo. (Courtesy Port of Sacramento Collection, West Sacramento Historical
Society and *Sacramento Bee*.)

In the early 1900s, an average of 84,000 tons of grain were shipped from various landings along the Sacramento River above Tehama south to Knight's Landing. Between Sacramento and San Francisco, steamboats also made several landing stops to load cargo. (Courtesy CSL/CHR.)

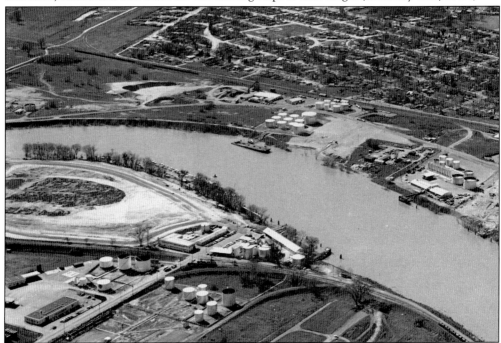

Petroleum products were delivered to the present site of the Tank Farm on the west side of the river and were transferred to floating barges. The Shell and Standard Oil Companies had several sites along the Sacramento River: Shell Oil on the Yolo side and Standard Oil on the Sacramento side. Standard Oil Company owned the steamer *San Jose*. The Yolo side of the petroleum farm is on the upper part of the river in the photograph. The Sacramento farm is at the lower left. (Courtesy CSL/CHR.)

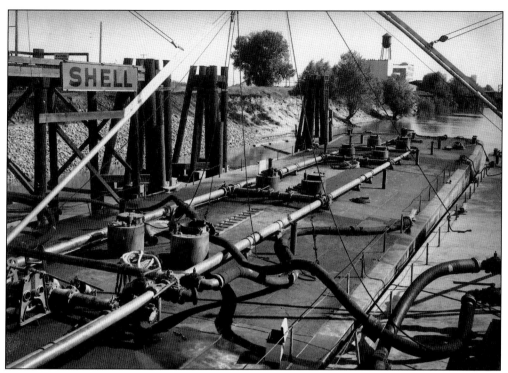

This is a close-up view of the Shell Oil Company transfer barge located on the Yolo side of the Sacramento River. As with the Rice Mill, pylons used in mooring barges along the riverbank are still visible. (Courtesy CSL/CHR.)

A barge with bails of hay is being towed downriver toward the Bay Area. The Rice Mill in Yolo County is in the background. Barge traffic was popular for moving freight. From 1910 to 1918, freight traffic increased from 500,000 tons to one million tons, an increase attributed to World War I. In the 1920s, freight increased, but passenger service declined due to the number of automobiles and highway improvements. (Courtesy CSL/CHR.)

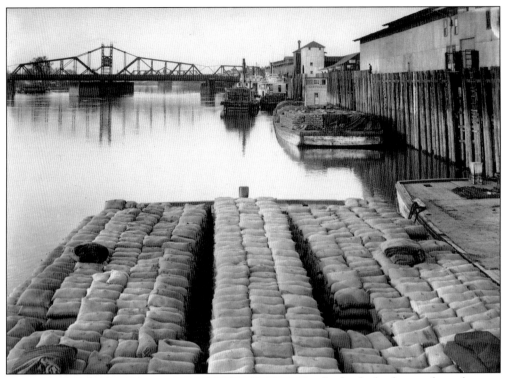

In the far background are the Southern Pacific Railroad I Street Bridge, the Sacramento Northern Electric Railroad M Street Bridge, and docked steamboats and barges on the Sacramento side of the Sacramento River. The middle barge is the *Kentucky*. (Courtesy CSL/CHR.)

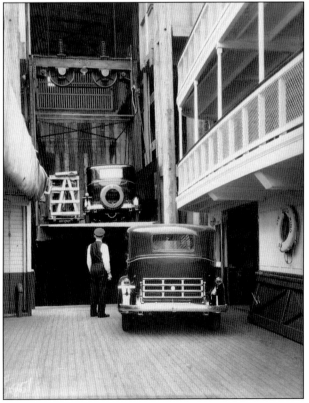

In the late 1930s, automobile traffic was increasing. In this photograph, automobiles are loaded by elevator onto the steamboat *Delta King*. After reaching their destination, passengers had the freedom to drive back to their point of origin. (Courtesy CSL/CHR.)

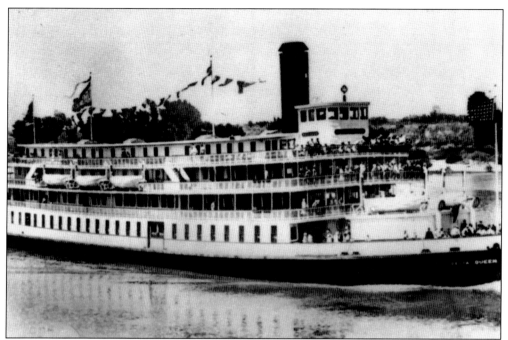

In 1924, the California Transportation Company began construction in Stockton on the *Delta King* and *Delta Queen*. Both were launched in 1927 and ferried passengers and cargo to and from the Bay Area. While one boat sailed from Sacramento, the other would start its trip up the Sacramento River from San Francisco. This photograph is of the steamboat *Delta Queen*.

A stern-wheeler steamer is plowing its way through the Sacramento River. The levee side of the river is lined with concrete for erosion control. In the early 1900s, when an average of 84,000 tons of grain a year was shipped from Sacramento to various landings along the Sacramento River, a typical trip took about 12 hours. Between Sacramento and San Francisco, steamboats made several stops to load and unload cargo. Some vessels, such as the *Modoc*, made approximately 30 stops during a one-way trip. Others, such as the *Navajo*, made three round-trips a week during daylight hours, stopping only 10 times each. Consequently, those trips took only eight to nine hours each way. (Courtesy CSL/CHR.)

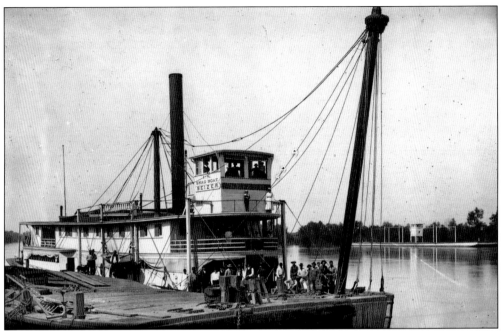

The U.S. snag boat *Seizer* kept the waterways safe by removing trees torn from riverbanks at high water. In this photograph, probably taken in the upper Sacramento River area, the *Seizer* docks while its crew takes a well-deserved break. Being a crew member on a snag boat was hazardous duty. These unsung heroes worked long hours pulling out logs and other floating debris that would have damaged a steamboat. (Courtesy CSL/CHR.)

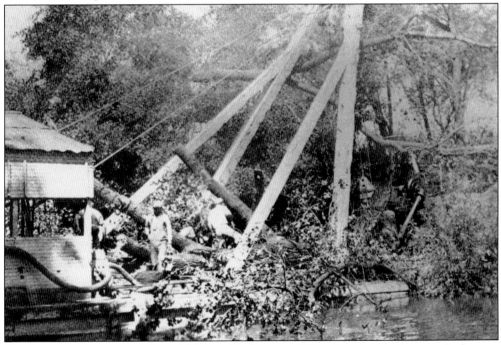

The *Seizer* kept the waterways free of debris and had a crew of Hawaiians. In this photograph, the snag crew is removing large trees and tree branches from the river. (Courtesy Yolo County Archives.)

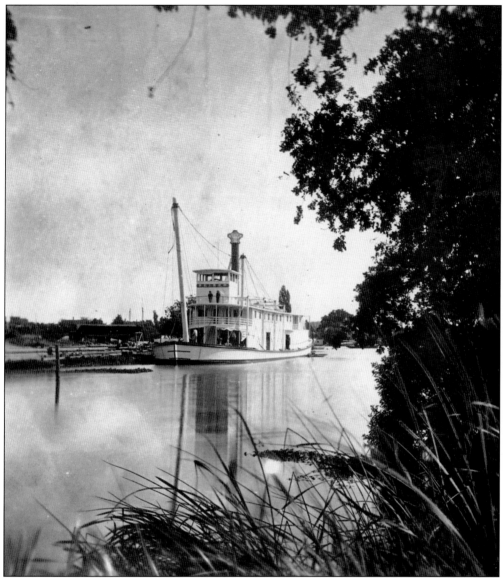

Most inland waterways that were used for commercial trade utilized government-operated snag boats to keep the rivers free of debris and other hazards. Here the U.S. snag boat, *Seizer*, is docked somewhere along the Sacramento River. (Courtesy CSL/CHR.)

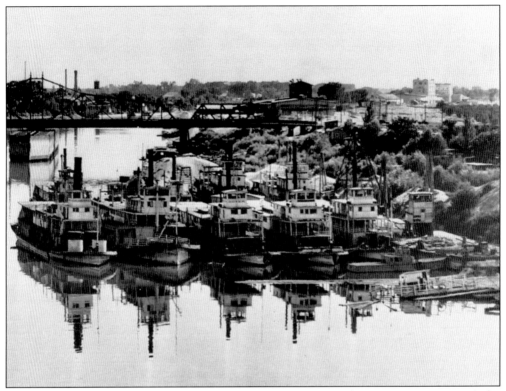

These are riverboats moored in the Sacramento River at Broderick in 1931. Later, in 1935, the Tower Bridge replaced the M Street Bridge, seen here in the background. The California State Rice Milling Company can be seen in the upper right.

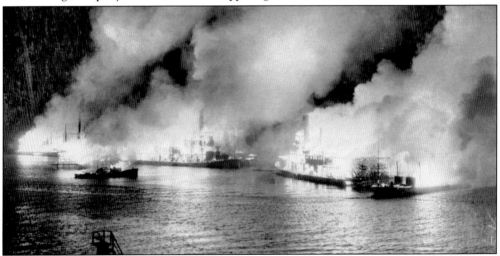

During the 1930s, the Sacramento Navigational Company shipyards were busy repairing and overhauling vessels. In 1922, the Broderick shipyard employed up to 40 employees. A suspicious and disastrous fire broke out August 28, 1932, destroying 13 steamboats and barges. The fire started with an explosion, and flames quickly spread from one wooden vessel to another. They were not replaced or repaired, signaling an end to an era. (Courtesy West Sacramento Historical Society and Yolo County Archives.)

# Two

# Lake Washington and Harbor Opportunities

Lake Washington, once called Washington Lake, is located about midway between the northern and southern borders of the City of West Sacramento. This long, isolated body of water may have been part of the Sacramento River long ago. Before the port was built, Lake Washington was popular with locals for fishing, boating, swimming, picnics, and dancing at the dance pavilion located there.

During the Army Corps of Engineers study and survey for a suitable canal route and port site, the lake became an important link between the planned 42.8-mile deepwater channel and the Sacramento River through a proposed barge canal and locks. It also allowed enough room for a turning basin and harbor for the large ships that would load and unload cargo at the wharves. The site also provided room for expansion to accommodate additional ships, storage, and transit operations. As a result of the project, most of the lake became part of the port facilities, while a remnant remains as a waterway that extends almost to the Yolo Bypass.

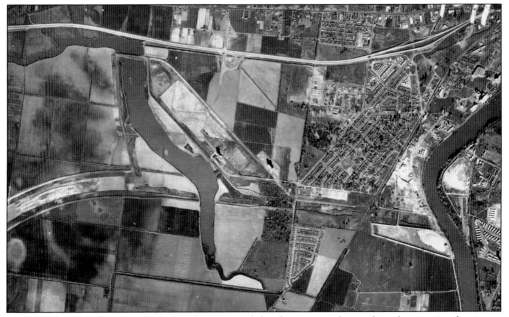

This 1954 aerial photograph shows the curve of the deepwater channel to the turning basin on the left. The initial port facilities, grain elevator, and rice-storage silos are seen just north of Lake Washington. At the top is Highway 40. In the upper portion of the lake in this image, the Port District Railroad line can be seen dissecting the waterway by way of an earthen embankment. The Sacramento River can be seen at far right. (Courtesy Cartwright Company.)

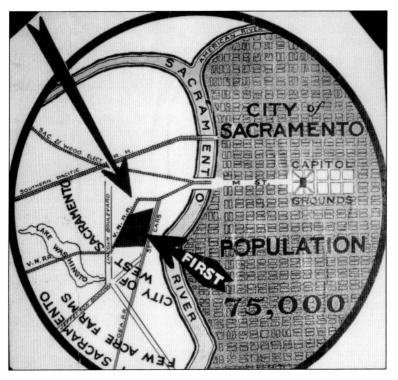

A 1913 West Sacramento Company–brochure map illustrates the site of the new community of West Sacramento City. (Courtesy Bryan Turner Collection, West Sacramento Historical Society.)

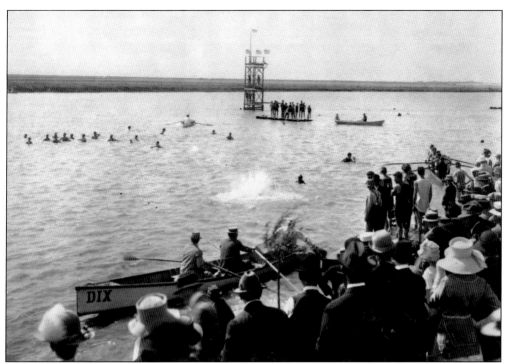

Swimming competitions were also common at Lake Washington. This swim meet was held in 1912. (Courtesy CSL/CHR.)

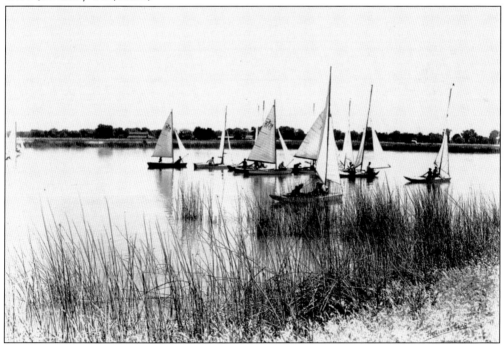

Sailboating was also done on Lake Washington in the early 1900s. Since the majority of the community lived north of the lake, this photograph is most likely facing south. (Courtesy Yolo County Archives.)

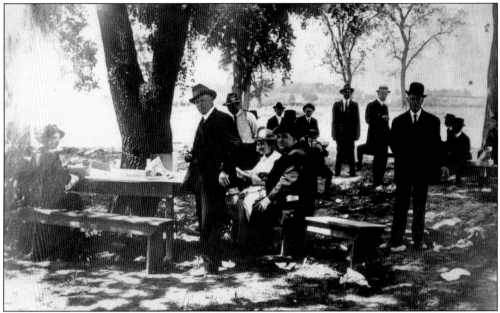

A visit to Lake Washington was one of the special features of the West Sacramento Company sales team in 1913. Limousines carried prospective buyers on these tours to encourage land sales in their new planned community of West Sacramento City. (Courtesy Bryan Turner Collection, West Sacramento Historical Society.)

A peaceful 1913 scene on Lake Washington illustrates the value of living in West Sacramento and commuting a short distance to work in Sacramento on convenient electric trains that had several stations throughout the area. (Courtesy Bryan Turner Collection, West Sacramento Historical Society.)

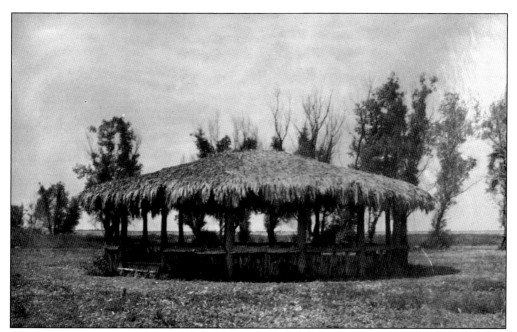

This thatched-roof structure was a dance pavilion and shaded retreat near Lake Washington through the 1930s. (Courtesy Bryan Turner Collection, West Sacramento Historical Society.)

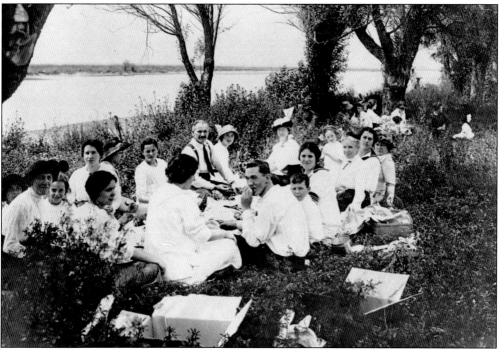

A group enjoys a picnic at Lake Washington, one of the special features of West Sacramento in 1913. The West Sacramento Company's fleet of limousines provided tours of the sites to show potential buyers the joy of fresh air, sunshine, fishing, boating, and all the healthful benefits of making a home in West Sacramento. (Courtesy Bryan Turner Collection, West Sacramento Historical Society.)

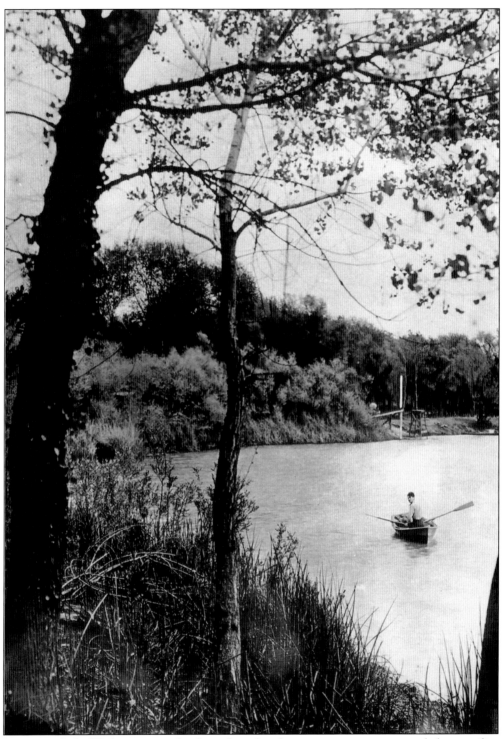

Boating on Lake Washington was less hazardous than boating on rivers, as it provided tranquility and peaceful recreation for boaters. (Courtesy Bryan Turner Collection, West Sacramento Historical Society.)

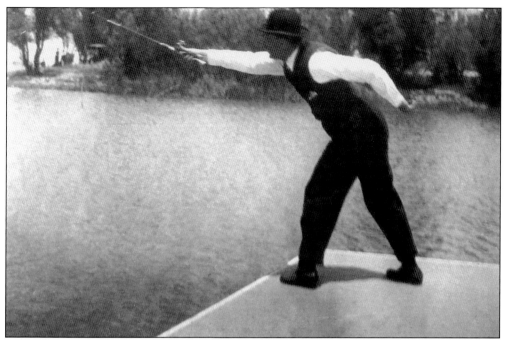

This was part of the West Sacramento sales tour of West Sacramento Company in 1913. Here a fisherman wearing a derby hat makes a cast and throws his fishing line into the lake. (Courtesy Bryan Turner Collection, West Sacramento Historical Society.)

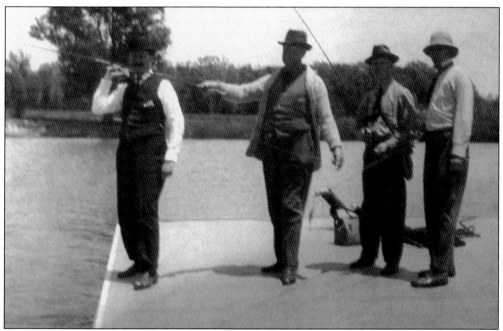

These well-dressed fishermen were most likely a part of the West Sacramento Company's prospective buyers' program, which brought people to the lake to promote real estate sales. (Courtesy Bryan Turner Collection, West Sacramento Historical Society.)

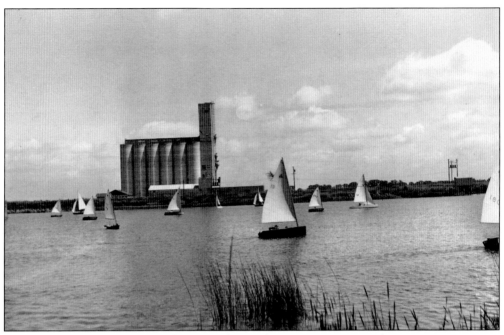

These are sailboat races taking place on Lake Washington on May 6, 1951.

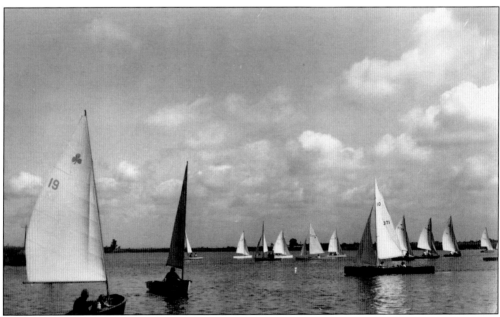

Regattas are still popular with the Lake Washington Sailing Club. Today area organizations include the Davis Rowing Team and the River City Rowing Club. Other than large vessels, motorized boats are discouraged from using the lake.

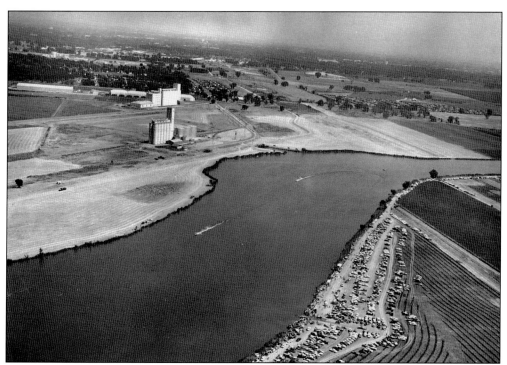

Speedboats race on Lake Washington with a bulk-grain storage facility visible in the background.

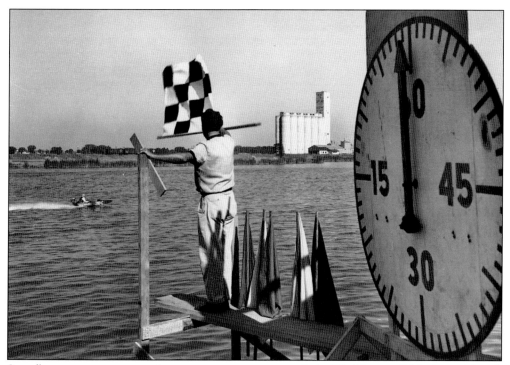

Speedboat regattas were another water sport common on Lake Washington. This time trial took place in July 1957.

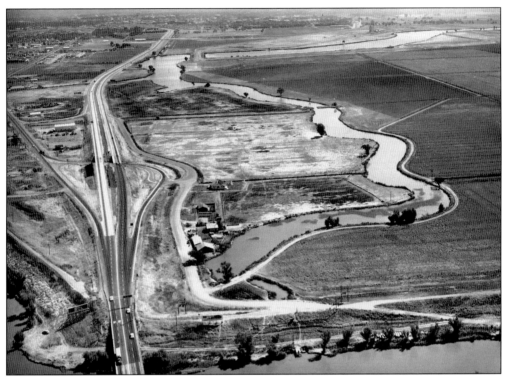

Looking east (left to right) is Davis Highway (now West Capitol Avenue), Highway 40 (Now Highway 80), and Lake Washington. In the upper right above the lake are the Farmers' Rice Growers Cooperative and the grain elevator.

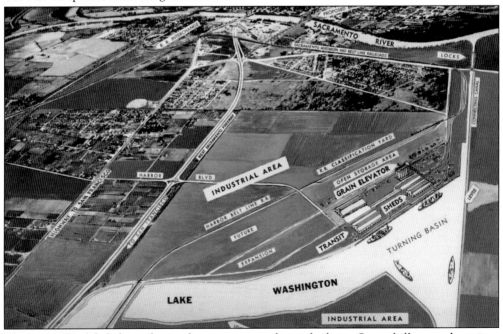

This is a 1950s labeled aerial map showing proposed port facilities. Several illustrated versions for the port were used in its promotion and marketing.

# Three

# BEGINNING OF THE PORT PROJECT, PLANNING, AND CONTRACTS

According to the *1993 Port of Sacramento Strategic Plan*, "The Sacramento–Yolo Port District was formed under a 1937 amendment to the Harbors and Navigation Code of the State of California, which permitted the creation of bi-county port districts. To date, the Sacramento-Yolo Port is the only port formed under this amendment." Congress authorized construction of the channel and harbor on July 24, 1946.

Local voters approved the formation of the district on April 5, 1947, by a vote of four to one, and the Sacramento-Yolo Port District was created. This new district included all of Sacramento County and District No. 1 of Yolo County. Five commissioners governed it, each serving four-year staggered terms. Two members were appointed by the Sacramento County Board of Supervisors, two by the Sacramento City Council, and one by the Yolo County Board of Supervisors. The original port commission of five members took office May 19, 1947. Later, after the formation of the City of West Sacramento, policies developed by the district were made by a seven-member commission. Sacramento County and City each appointed two and jointly appointed one additional member. Yolo County and City of West Sacramento each appointed one.

Funding for land acquisition and construction was provided by federal and state appropriations and with general-obligation bond issues approved by district voters. The port district had the responsibility of providing the property the Army Corps of Engineers required for construction. They retained the services of Gil Mellin, an engineer with the State Reclamation Board, to negotiate land acquisitions. In 1949, the Army Corps of Engineers began construction of the ship channel, harbor, barge canal, locks, and bascule bridge across the barge canal. The first construction phase was the enlargement of the channels on the east and west sides of Liberty Island in the lower Yolo Bypass. The enlargement would compensate for the new deepwater channel encroachment on the bypass. Construction continued until the opening of the port in 1963, except for an interruption of five years during the Korean War.

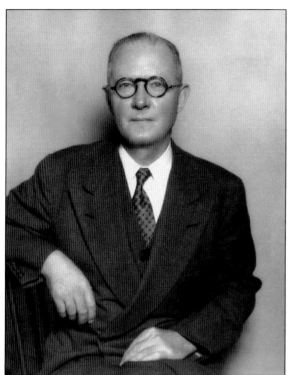

William G. Stone's career interest for a port began with a ceremony in December 1916. At this dedication, California's governor, Hiram Johnson, placed the first survey stake for a Sacramento ship-canal study. During that event, Governor Johnson made a comment that created a lasting impression on the young Stone. He said, "If you want something done, go and do it—obstacles need not deter you." Sixteen years later, Stone became manager of the Transportation and Industrial Department of the Sacramento Chamber of Commerce. Through his dedication and association with the chamber, Stone took the governor's advice and since has been known as the "Father of the Port."

To foster the idea of a seaport, William G. Stone arranged for the SS *Harpoon*, a freighter out of Boston and New York, to sail up the Sacramento River. After 13 hours of carrying various cargo to Sacramento, on March 22, 1934, the SS *Harpoon* docked at the River Lines dock at Front and N Streets. Two days later, it took only nine hours to return to San Francisco. The trip included two tugs, one at the bow and the other on the stern, to maneuver the sharp river turns. (Courtesy Port of Sacramento Collection, West Sacramento Historical Society and *Sacramento Bee*.)

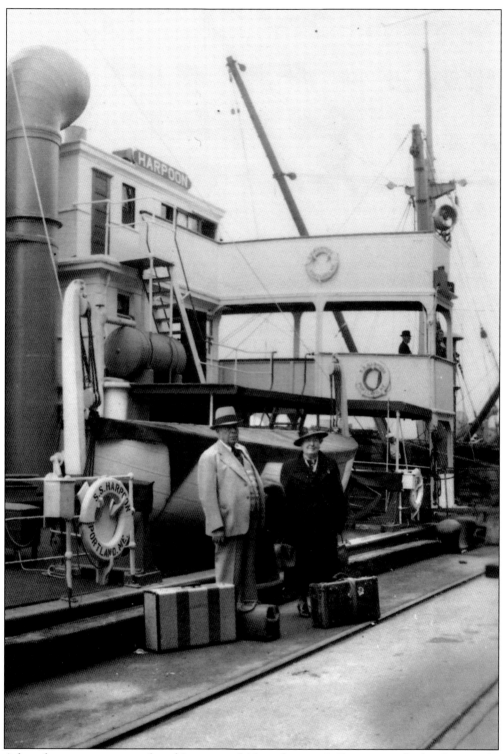

A few select passengers toured on this voyage, which made a stop in Sacramento. In this photograph, the SS *Harpoon* makes a stop in New York City before sailing to the West Coast.

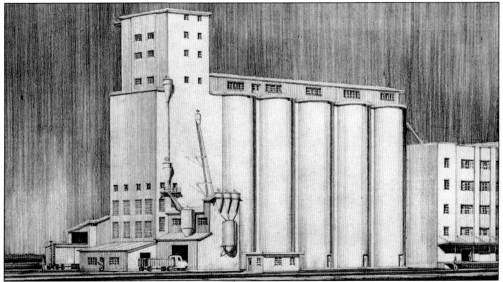

This is an artist's illustration for the future grain-storage facility designed by the firm Homan and Lawrence. It would be one of several first port facilities constructed.

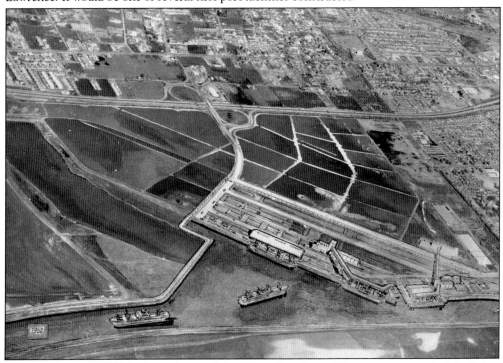

This is a late 1962 architect's rendition of the $55 million Port of Sacramento terminal facilities. In the foreground is the turning basin. The barge canal and navigational lock is on the right connecting to the Sacramento River. Two transit sheds and an open cargo wharf are seen in the foreground; the berths and barge slips for bulk grain and rice were also a part of this initial project. On the extreme left is the transit shed for future development. Also seen is the conveyor system connecting the grain elevator (center) and the plant of the Farmers' Rice Growers Cooperative, deepwater berths, and barge slips. (Illustration by Wayne Frederick.)

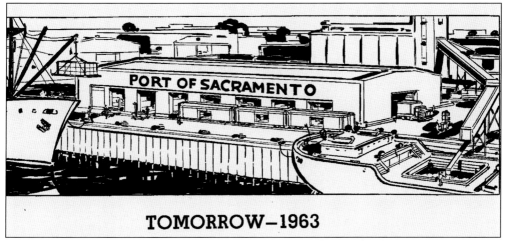

## TOMORROW—1963

This is one of several illustration concepts for the port. When built, the Port of Sacramento would be the first new seaport constructed in 30 years in the United States and would provide steamship companies the modern services of its day.

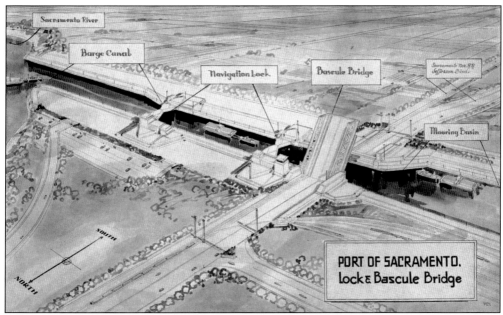

Here is a March 1956 artist's concept of barge canal, navigational lock, bascule bridge, and mooring basin. The barge canal and lock was the only navigational canal in between the deepwater and the Sacramento River. The gates would be 45.5 feet high and were, at that time, the largest in the world. The bascule bridge would be the only connection between West Sacramento and the Southport region. The Army Corps of Engineers illustrated this concept.

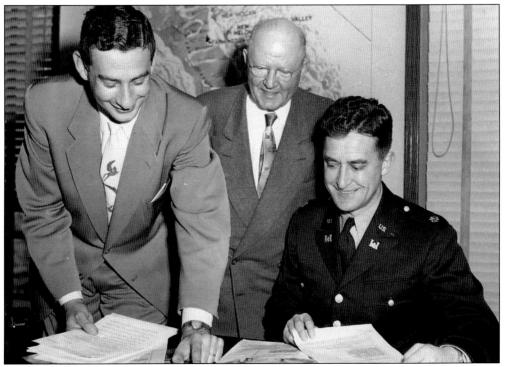

Port engineer Melvin Shore (left), William G. Stone (center), and assistant district engineer Colonel Hamerly sign an agreement to acquire land on December 28, 1956. During that year, a total of $1.5 million was spent to purchase 5,900 acres of right-of-way property. Overall, there were over 100 individual acquisitions of property.

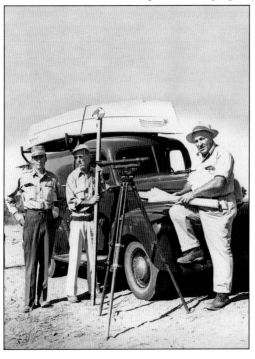

A survey team maps out the direction of a deepwater canal and site for turning basin excavation. Both private companies and the Army Corps of Engineers made various plans and surveys. In 1945, the U.S. District Engineers in Sacramento completed their survey and recommended a feasible route for a 30-foot-deep ship channel. The channel would be dredged from Lake Washington and connect with deepwater near Suisun Bay. The chief of the Army Corps of Engineers approved the plan. This was followed by numerous public hearings in both the house and senate congressional committees. The construction of the canal was authorized in Public Law 525 of 79th Congress, Chapter 595, Second Session. The act stipulated that local interests and governments would furnish all right-of-way maps and that Lake Washington be constructed to maintain a large turning basin on the adjacent port and terminal facility. This photograph was taken in August 1955.

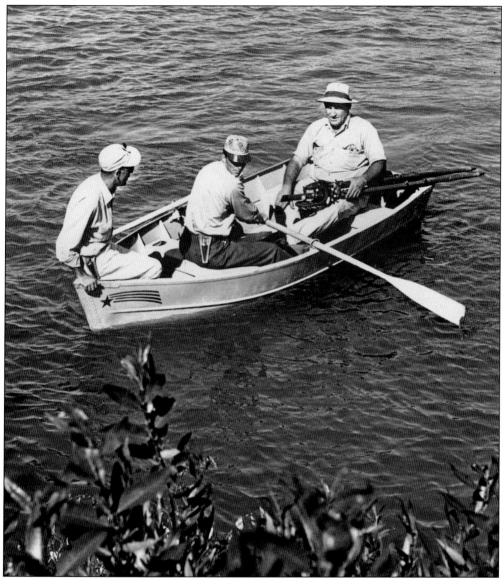

Near Liberty Island, the survey team was unable to use their vehicle and had to be transported by boat. The delta area is traversed by over 1,000 miles of waterways and sloughs. This photograph was taken somewhere between Lindsey Slough and Miner Slough in Solano County.

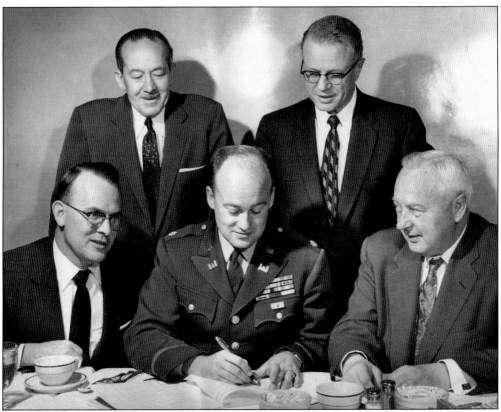

Signing the Liberty Island Contract to begin excavation at Sacramento's Sutter Club, on April 6, 1956, from left to right, are the following: (first row) Congressman John Moss; Colonel Wilder; Paul Cushing, president of Hydraulic Dredge; (second row) Roy Dreary and Carl Lawrence.

A Sacramento Chamber of Commerce sign promotes the economic benefits the port will bring into the area.

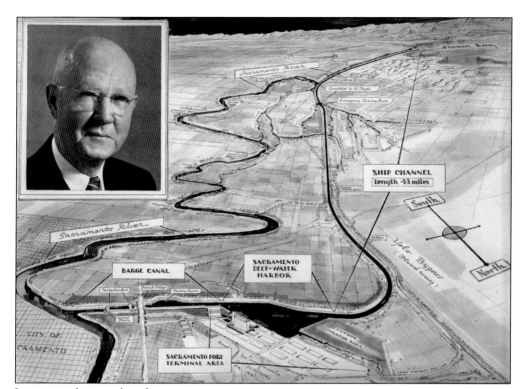

Layout graphics used in the *Sacramento Union* newspaper promote the port.

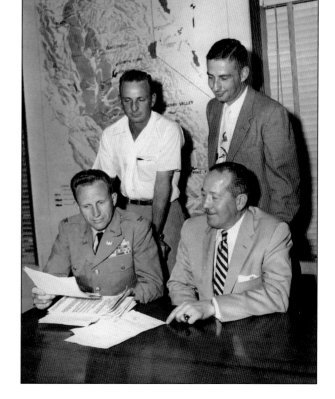

In attendance at the toe-drain bid opening on May 28, 1958, are the following: (first row) Colonel McCollam and Roy Deary, chairman of the port district; (second row) E. Luhr of Luhr Construction in Columbia, Ohio, and assistant port engineer Melvin Shore.

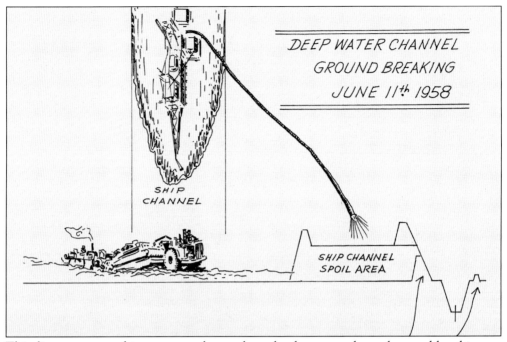

This diagram was used in a press packet to show the deepwater-channel ground breaking on June 14, 1958.

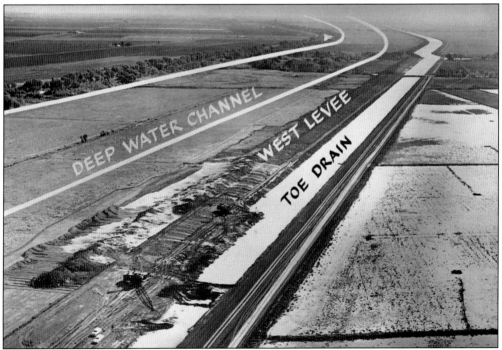

Facing south, a retouched photograph taken in October 1957 illustrates the deepwater channel, the west levee, and the toe drain. The toe drain was designed to facilitate the drainage of the Yolo Bypass when floodwaters receded as well as to compensate for the encroachment on the cross-channel area of the bypass.

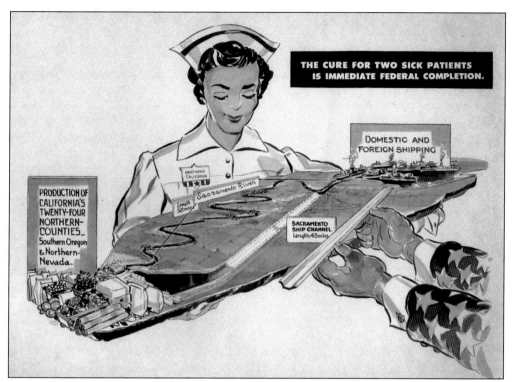

Submitted as Exhibit 10 for the Sacramento Deep Water Channel Appropriations Hearings of March 1956, this illustration is promoting the anticipated port and channel. It shows the potential commodity to be transported through the deepwater channel. The local government expressed the urgency for additional federal-government financing.

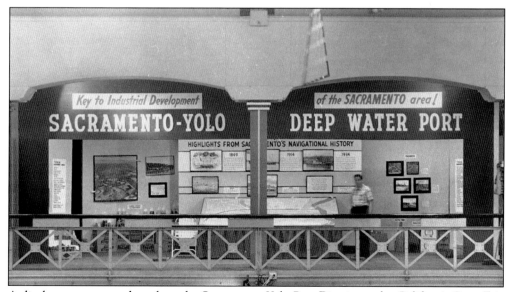

A display promotes and markets the Sacramento-Yolo Port District at the California State Fair in the 1950s.

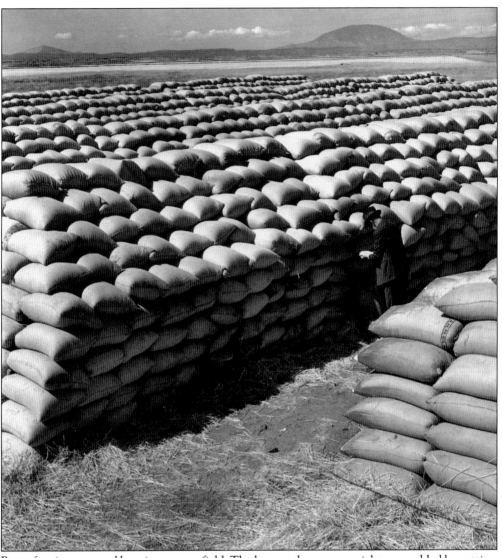

Bags of grain are stored here in an open field. The bags to the extreme right were added by cutting and pasting over the original photograph. This retouched image was used as a marketing tool to show the need for warehouses.

The following 1939 *Port Fact* pages project how much growth in population and agricultural returns the newly created Sacramento-Yolo Port District trade growth would provide to Sacramento. The projection is to 1947.

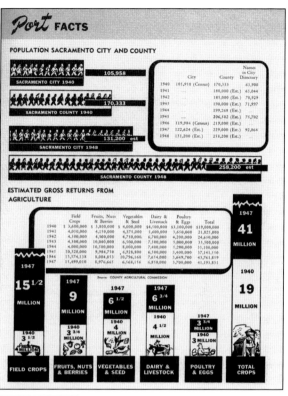

For promotions, this map was used in advertising the need for a local port that would serve northern California, southern Oregon, and Nevada. A deepwater channel and port would provide opportunities for local commerce. This map shows the potential source of resources and areas of trade for the Sacramento-Yolo Port District. California commerce includes lumber, mining, farming, olives, wheat and barley, grapes and wine, dairy products, rice, orchard products, canned products, and asparagus.

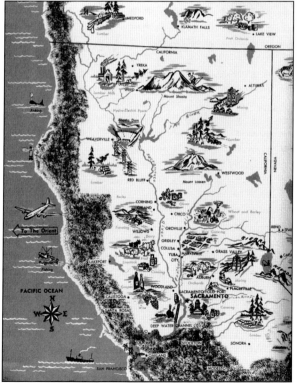

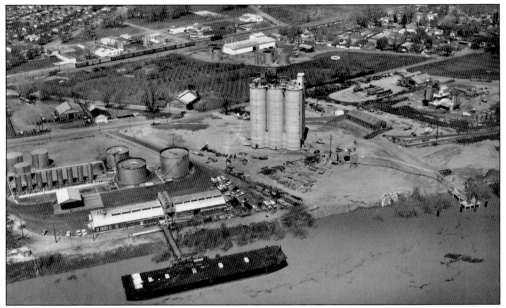

The tank farm and the cement plant on the west side of the Sacramento River have become entrenched in the history of the port. Barges used to carry fuel up the Sacramento from the Antioch area to be stored in the tanks for further distribution. The cement plant became an important segment to port construction. Known earlier as a batch plant, it provided concrete for construction of the grain elevators, storage facilities, and dock.

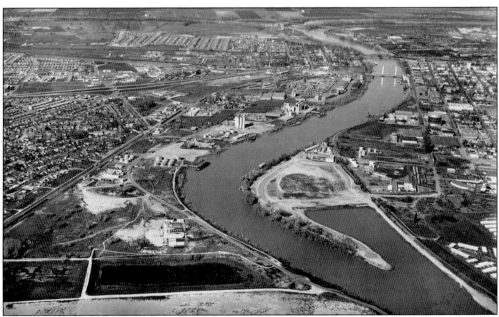

This is an aerial view of the cement plant as seen in the late 1950s. Note the railroad tracks that were relayed and routed to the port. Today the cement plant and tank farm (on the right) will be removed and relocated to the new port to make way for river development.

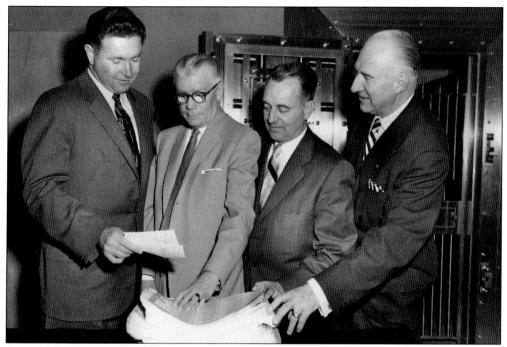

Posing, from left to right, with the $1 million port bond at the Sacramento City Treasurer's Office are C . E. McCarthy, manager of the Capitol Office, Bank of America; Ray Houston, treasurer; R. N. Crowell; and Earl Lee Kelly, the vice president of Bank of America.

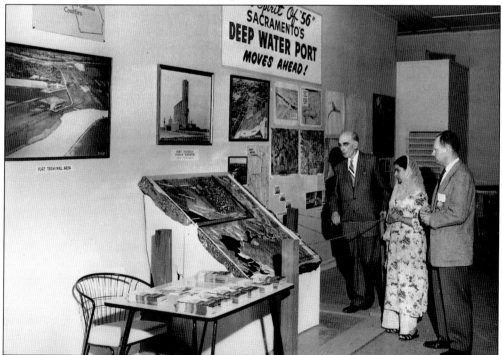

Promotion of trade services that will be provided by the port are displayed during the California State Fair in September 1956.

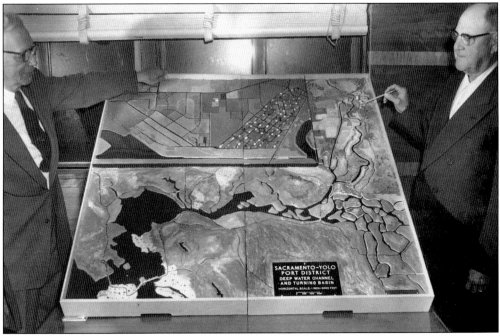

Used for public relations and port marketing, this model shows the Sacramento–San Francisco Bay Delta area and channel and the enlarged detail of the proposed port harbor and barge canal and locks connection of the Sacramento River around the 1950s.

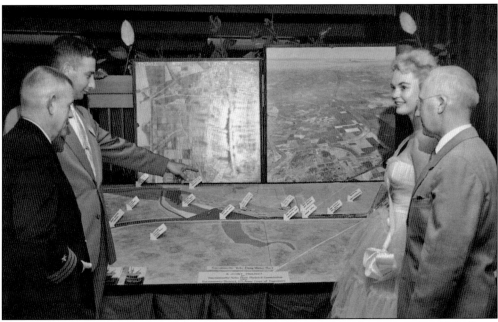

Assistant port director Melvin Shore (second from left) points to the Sacramento-Yolo Deep Water Port map during Public Relations Day at the Sacramento Signal Depot on February 27, 1958. This would be a joint project of the Sacramento-Yolo Port District Commission and the Sacramento District U.S. Army Corps of Engineers. The arrow flags on the model identify the future port facilities and boundary.

Contracts were constantly in the works to attract shipping lines and commodity for storage and transport. Within 100 miles of Sacramento there were four million people and a big potential market of goods and services. More than 52 percent of California's agricultural products were produced there. In addition, at least 95 percent of California's timber was being produced in northern California.

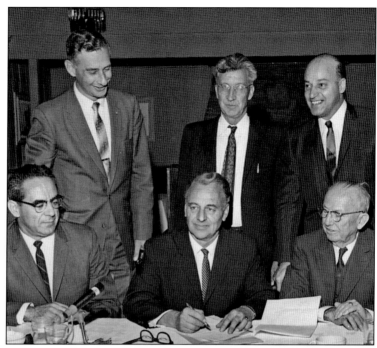

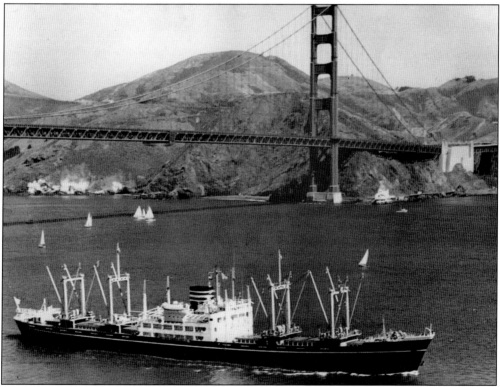

Negotiations with shipping companies from numerous countries throughout the Pacific, Central America, and Europe were vital to the success of the port. In this photograph, a freighter is sailing under the Golden Gate Bridge into San Francisco Bay.

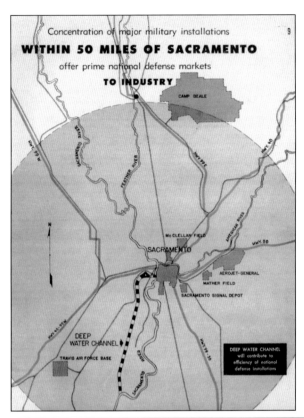

Concentration of major military installations

# WITHIN 50 MILES OF SACRAMENTO

offer prime national defense markets

## TO INDUSTRY

CAMP BEALE

McCLELLAN FIELD

SACRAMENTO

AEROJET-GENERAL

MATHER FIELD

SACRAMENTO SIGNAL DEPOT

DEEP WATER CHANNEL

TRAVIS AIR FORCE BASE

DEEP WATER CHANNEL will contribute to efficiency of national defense installations

The port was also seen as a needed facility for supporting the military and would contribute to the economy and efficiency of the area. This map, used as Exhibit 7 of the Sacramento Deep Water Channel, Appropriations Hearing of 1956, shows six major national-defense installations within a 50-mile radius of the port.

On several occasions, port-district and state- and local-government officials made trips to Washington D.C. seeking federal support to complete dredging the deepwater channel and navigational locks.

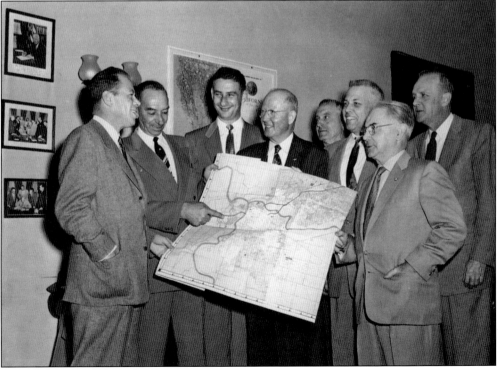

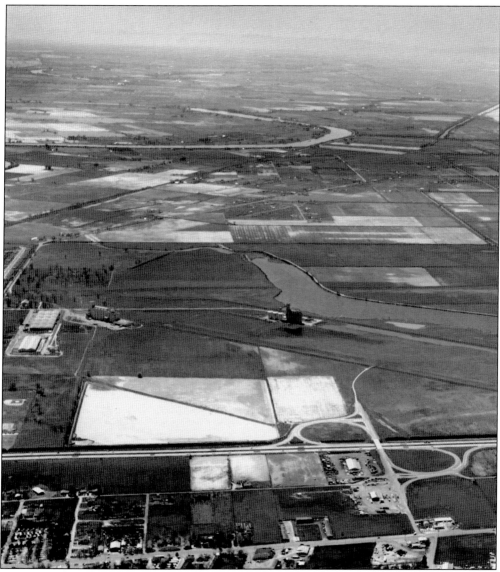

This is an aerial view of the port with the grain elevators near the center of the photograph on the edge of Lake Washington. At the lower right are Highway 40 and the Harbor Boulevard Interchange. The south end of Harbor Boulevard reaches the entrance to the port at Industrial Boulevard.

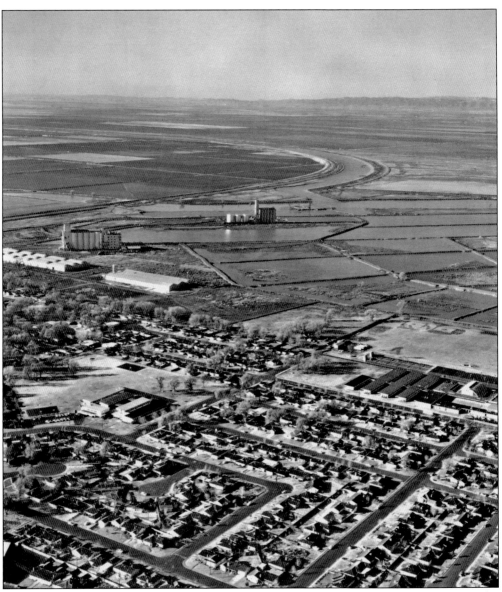

This view is facing southwest toward San Francisco and the Bay Area in the mid-1950s. Note the water surrounding the bulk-grain storage facility located in the center. These are dredge ponds. During the channel dredging near the port, the material would be discharged as landfill. It would then evaporate, leaving soil as fill material.

# Four

# SACRAMENTO-YOLO PORT DISTRICT AND CONSTRUCTION

Ground breaking for the port project began on August 7, 1949, with the construction of a grain elevator. Other terminal facilities completed in 1950 included a rice mill, several large warehouses, and a railroad yard. When the Korean War halted further funding, dredging and earthmoving continued, using the initial funds. Then, in 1955, Pres. Dwight D. Eisenhower signed an appropriations bill that released $500,000 for more work on the project. In 1957, $2 million was added to restart the channel deepening. On December 14, 1959, a dredger broke through from the deepwater channel into Lake Washington, which became the Port's turning basin.

By 1961, more financing was needed for completion of the project and a $10 million bond issue, which passed by a seven-to-one margin, provided the funds. Obviously this project still had wide support. In March 1962, the first pile was driven to start wharf construction. By the following spring, two transit sheds and the open dock were completed. The total cost was $45 million in federal funding and $15 million from state and local funds.

Seated from left to right are Colonel Gorlinski, Colonel Potter, and Earl Whithy Combs. Standing in the background is William G. Stone, and Congressman Leroy Johnson is speaking to the 5,000 spectators who attended the port ground-breaking ceremony of the $18 million project. A month after the ceremony, bids were taken to construct a 500,000-bushel-capacity grain elevator that was completed in May 1950. Three more storage tanks were later added, bringing the total capacity to 875,000 bushels.

These photographs show the ground-breaking ceremony for the initial port facilities consisting of a grain elevator and warehouses.

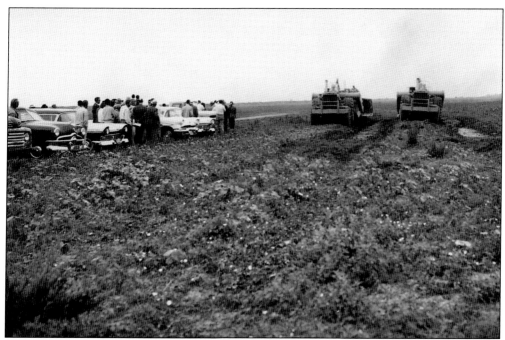

From left to right in this ground-breaking ceremony photograph are Robinson Crowell, Colonel McCollum, William Stone, and William H. Johnson, the past president of Sacramento City/County Chamber of Commerce.

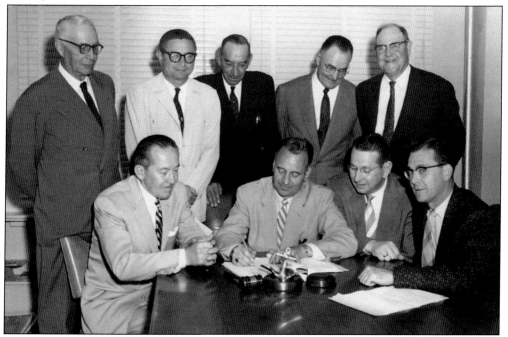

Various agreements and contracts were negotiated before and during port construction. They involved the right-of-way purchases, establishing the financing for construction, bidding to begin work, approval for a localized labor union, rice and grain contracts, warehouse-space allocations, and shipping commitments.

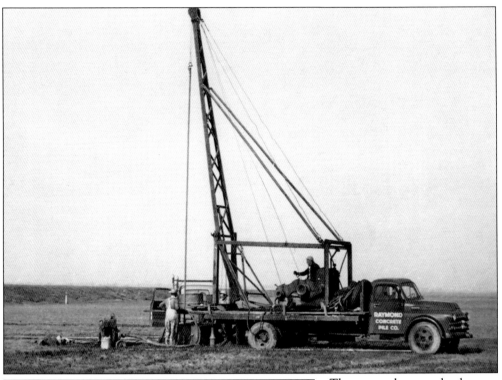

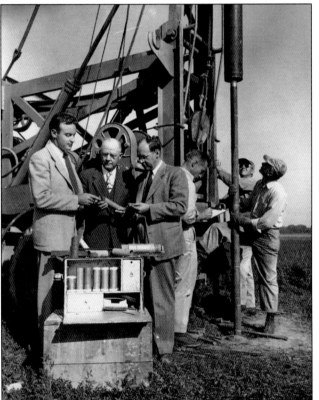

These two photographs show the first phase of construction. At various locations, soil-core samples were taken to determine whether the site could support the weight of building structures, determine the level of water table, or help determine whether the compacted soil could retain water for a levee system for a channel. In some cases, test piles were driven into the ground to confirm the engineered load values for each concrete pile and would determine the final length of foundation needed for the piles.

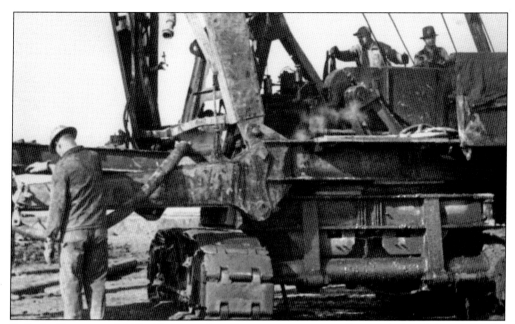

Built by Barrett and Hilp Construction Company, concrete piles are being driven into the ground. When completed, the piles would support the foundation for the massive grain elevator. In addition, the grain elevator required the construction of road and rail facilities and utilities, including natural gas for the grain drier.

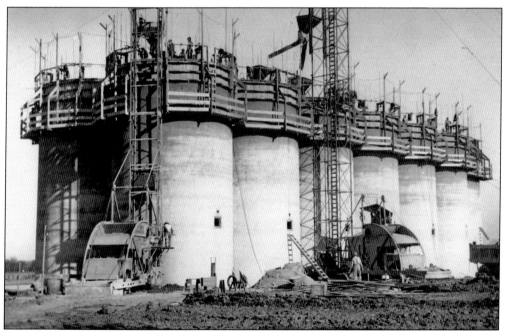

Beginning in 1949, the first facility constructed was the grain elevator. Completed in 1950, this elevator has the capacity of storing 875,000 bushels of grain for ship loading. The project cost $700,000 to construct.

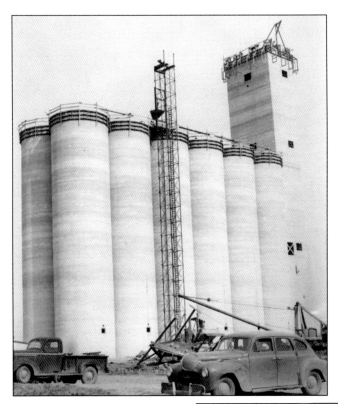

This April 12, 1950, photograph looks northeast on the nearly completed grain elevator. When completed, this would be the only leased facility within the port, and it was leased to Cargill, Inc., an international agribusiness, until 2000. The port currently operates this grain facility.

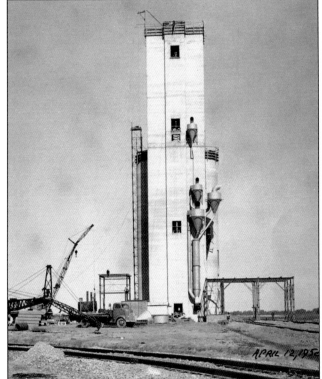

In this western view of the grain elevator, note the framing on the right for the enclosed dump shed. Grain would be delivered by railroad cars or by bottom dump trucks.

The completed grain elevator and storage sheds were used to house both bulk and bagged grain. Rail cars were emptied several at a time, dumping the contents into a conveyor system and dispersing it into the towers and tanks section.

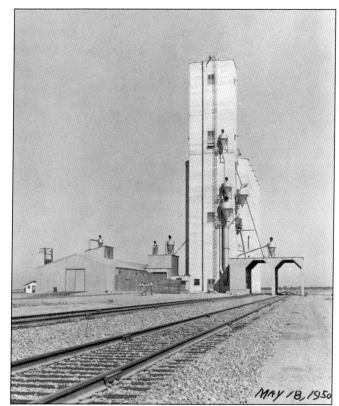

After the port facilities were constructed, the harbor was next. In this photograph, the Army Corps of Engineers and port administrators tour the future harbor site of Lake Washington.

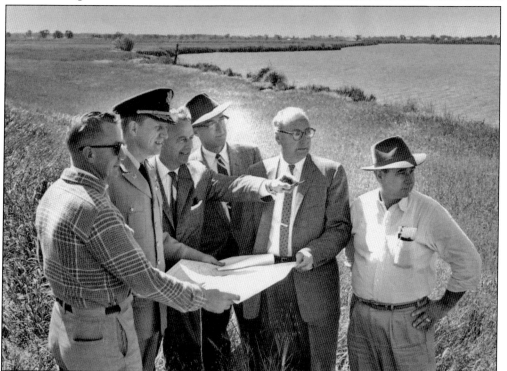

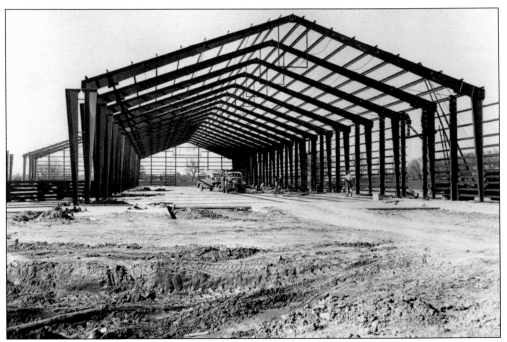

This is the foundation and steel frame of the Rio Bonito Warehouse. Located on a five-acre site, this was the first storage building constructed near the port.

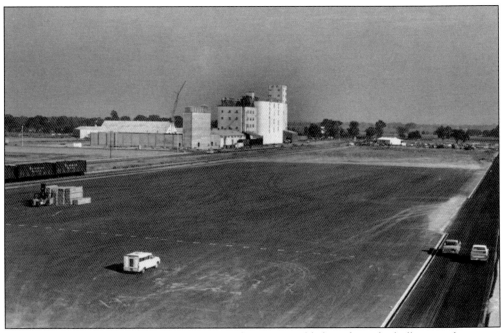

The Farmers' Rice Growers Cooperative grain elevator is visible here from the bulk-grain elevator.

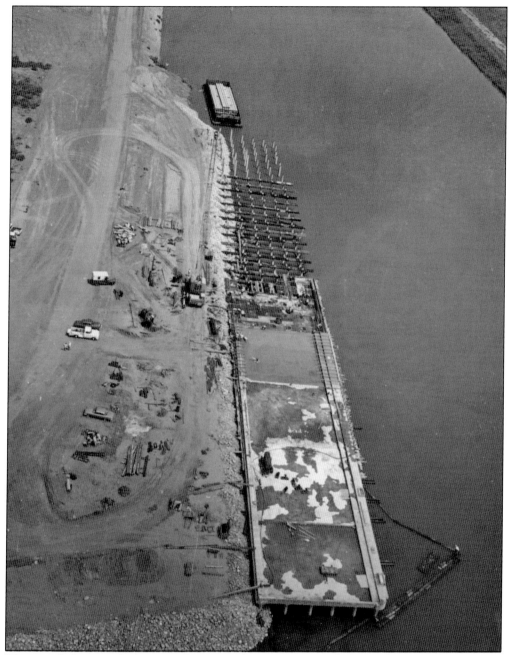

This aerial photograph shows workers smoothing concrete and placing forms on the concrete deck for a new wharf.

The Rio Bonito Warehouse (framed) and portions of Haslett Warehouse were built using private funds. This photograph was taken from the Farmers' Rice Growers Cooperative Building on April 5, 1957. In the middle of this photograph is the future site of the Farmers' Rice Growers Cooperative facility expansion.

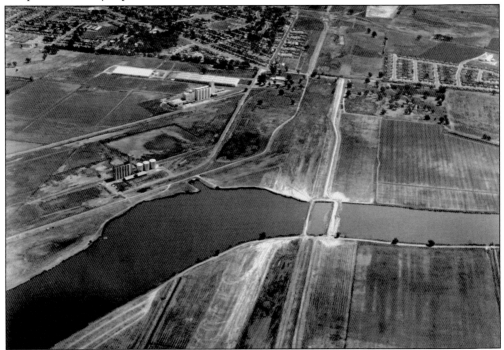

This aerial view shows the first completed port facilities: the port bulk grain elevator, the Farmers' Cooperative Rice Mill, and the public warehouse. A dam was constructed between the proposed turning basin and lower section of Lake Washington.

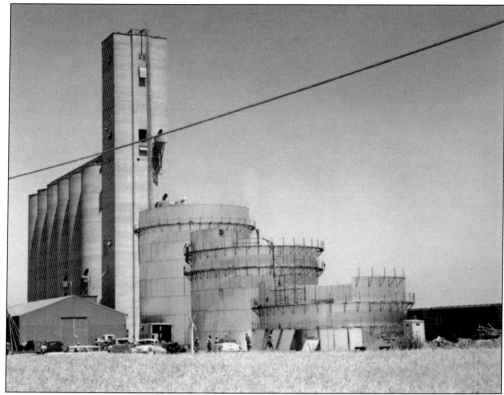

In 1957, additional storage tanks were constructed and added to the grain elevator to increase storage capacity. This photograph also shows the port-district grain crop of barley being produced right up to the tanks and elevator facility. As part of the port's long-range program, this elevator would have a capacity of two million bushels when the deepwater channel was completed.

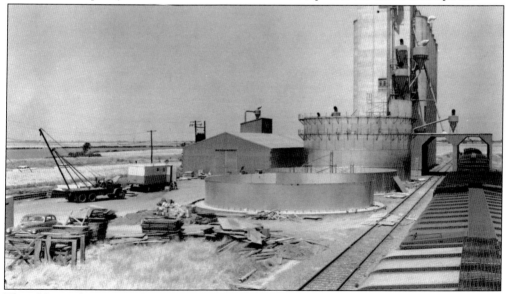

The additional storage tanks are under construction in the view looking west. The facility would be the only leased site with the port boundary.

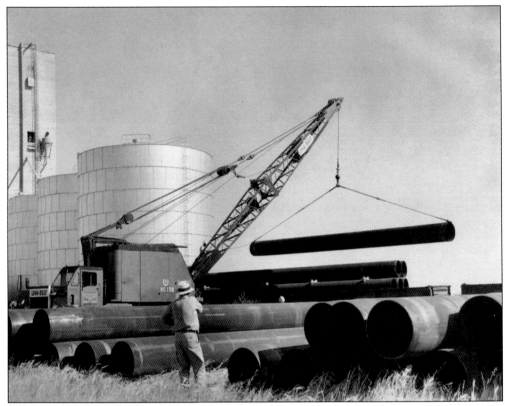

Pipe is unloaded near the new grain-storage tanks. This pipe would be used for dredging the deepwater channel. The dredged material would be discharged away from the channel construction site.

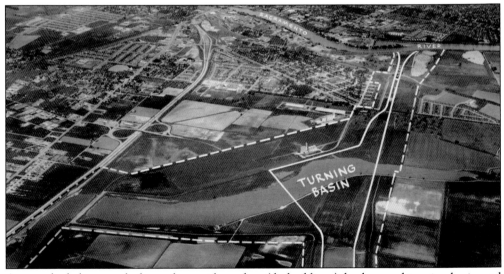

A retouched photograph shows the port boundary (dashed lines), harbor, and turning basin and barge-lock facilities to the Sacramento River. After the initial port facilities were completed, the local governments and port district waited for federal-government commitment to build the much-anticipated deepwater channel and barge canal.

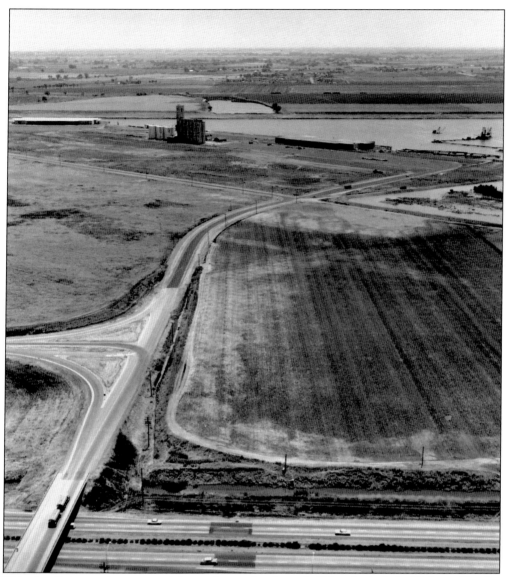

This view, facing southwest toward the newly completed port facilities, also includes Highway 40 at the bottom with Harbor Boulevard and overpass. Today this area is under commercial development.

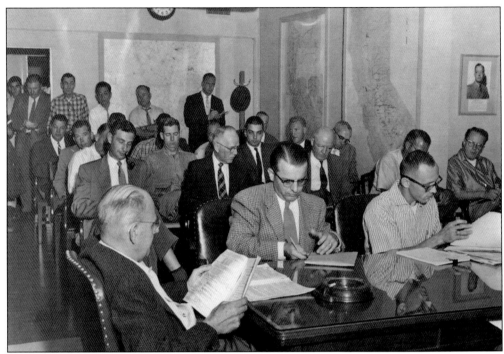

The bascule bridge and lock bid opened on June 24, 1958. The final contract was awarded to Rothschild, Roffin, and Weirich, a joint venture between Yolo Consolidated Industries and George Pollich and Company.

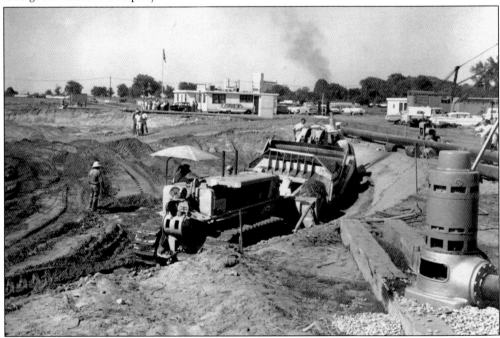

Heavy equipment begins excavation for the barge canal and the lock and bascule bridge. In the background is the field office for the Army Corps of Engineers. A sump pump is on the extreme right to drain groundwater.

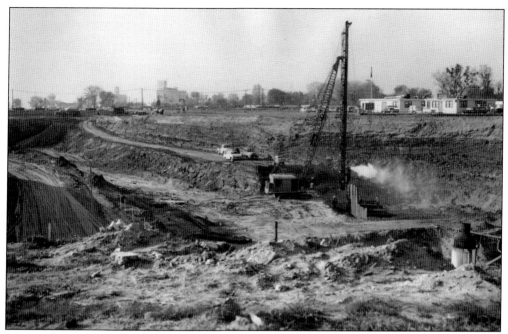

Piles are being driven for the foundation of the gate-and-lock structure. The bulk-grain elevator and Farmers' Rice Growers Cooperative can be seen at the left, and the Army Corps of Engineers field office is on the right.

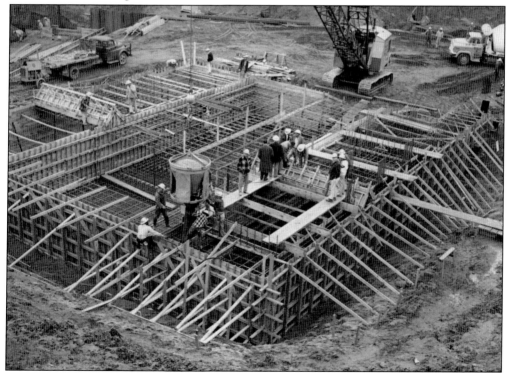

Here is the steel and framed concrete foundation for lock gates. This was the first concrete placement for the lock-and-gate contract.

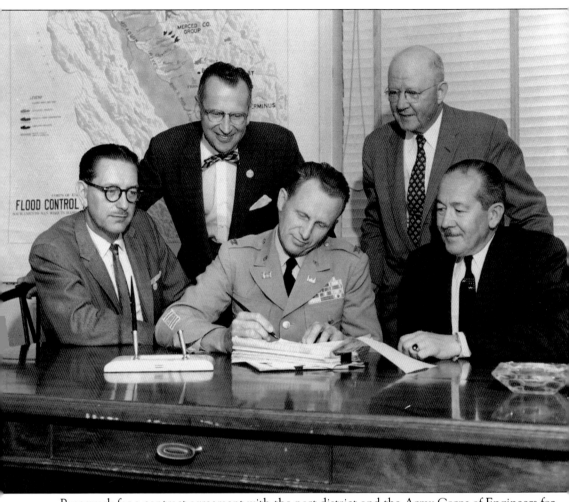

Paperwork for a contract agreement with the port district and the Army Corps of Engineers for lock-and-gate operations contract is being signed. William Stone, second from right, observes.

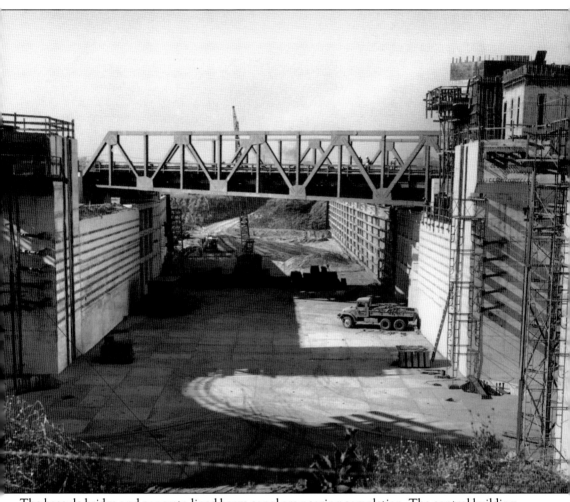

The bascule bridge and concrete-lined barge canal are nearing completion. The control building is on the right. Because the port's water levels at the turning basin and the Sacramento River differ as much as 21 feet, the navigational locks allow barges to pass through. The barge canal is the only inland canal with navigational locks in California, though it is no longer operational.

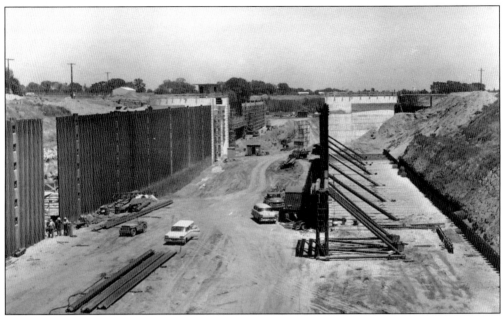

When construction of the barge canal began, steel walls were erected. Backfill of rock and soil were later added on the outside walls for support.

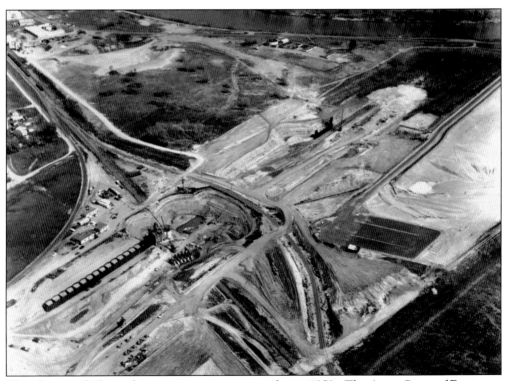

This photograph shows the port excavation process during 1950s. The Army Corps of Engineers headquarters can be seen to the left of the construction area.

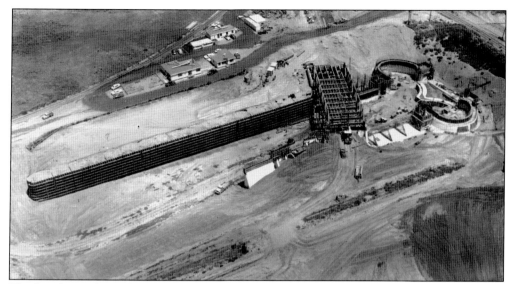

The foundation that will support the bascule bridge and navigational locks are under construction in this 1950s photograph.

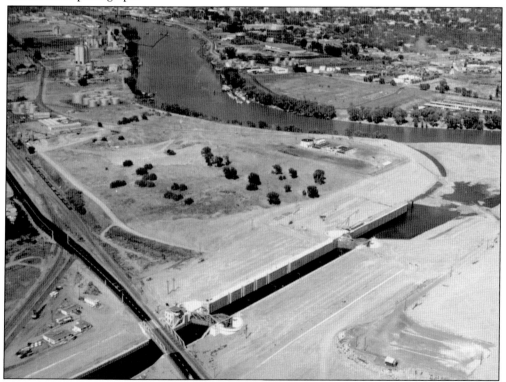

This aerial view facing east shows the completed concrete-lined barge canal and locks connecting to the Sacramento River. The locks, acting like a stairway, would flood with water to raise a vessel to or from the river and port. The completed barge canal was 640 feet long and 86 feet wide. The river is the natural boundary separating Sacramento county (on the right) and Yolo county (on the left). The road in the foreground is Jefferson Boulevard, and to the left of it is the field-maintenance office for the Army Corps of Engineers. (Courtesy Port of Sacramento.)

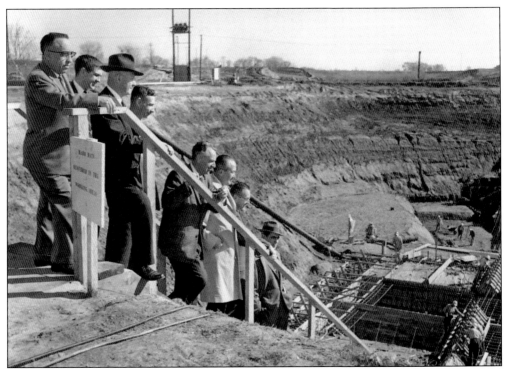

The port commissioners' tour of the first concrete placement for the bridge occurred on January 29, 1959. Pictured here from left to right are commissioners Wayne Smythe, Mr. Baker (counsel), William Stone, Melvin Shore, Robinson Crowell, Roy Deary, Ivory Rodda, and Mike Elorduy. Since this was the biggest project undertaking of its time, many official tours by local business owners, dignitaries, and politicians were a common sight.

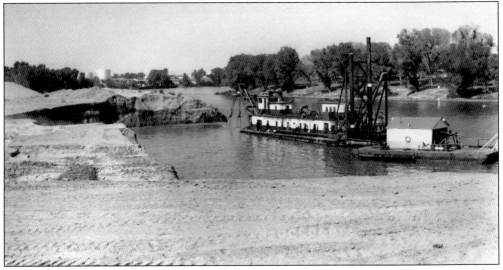

Two dredges cut through the Sacramento River levee to provide entrance to the barge canal in this September 23, 1961, photograph. Miller Park can be seen in the right background, and the dredge in the foreground is from Olympia Dredging Company in San Francisco. (Photograph by W. G. Stone; courtesy Port of Sacramento Collection, West Sacramento Historical Society.)

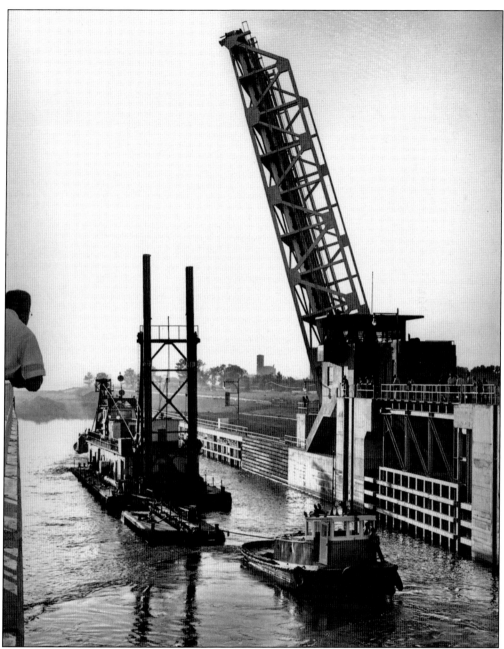

A dredger is being towed by a tugboat through the barge canal toward the locks. The drawbridge spanning the canal connects Jefferson Boulevard. This photograph is facing west toward the port and turning basin. The bridge-and-locks-tender building is on the right. (Courtesy Port of Sacramento.)

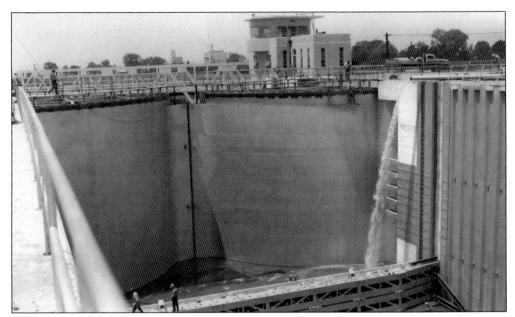

A test is performed on the completed swing-type lock gate. The gates are closed and water is being added to raise the water level. In that year, the lock's 45.5-foot-high gates were the highest in the world. The official name of the locks became the William G. Stone Navigational Lock in honor of the "Father of the Port."

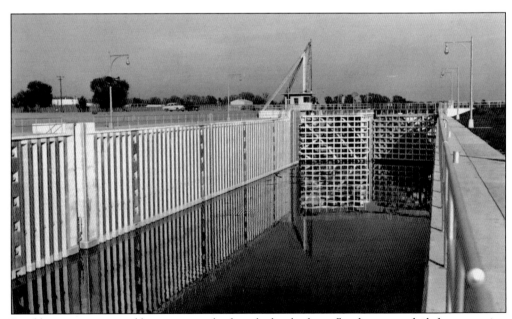

In addition to raising and lowering vessels, these locks also keep floodwaters and silt from entering the turning basin and deepwater channel.

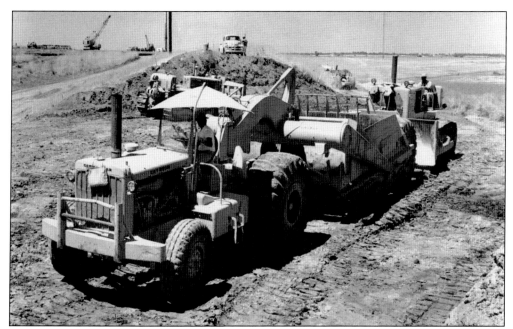

Bulldozers and heavy equipment were also used in excavation of the port facilities. In this photograph, a dozer is pushing an excavator through hard clay soil.

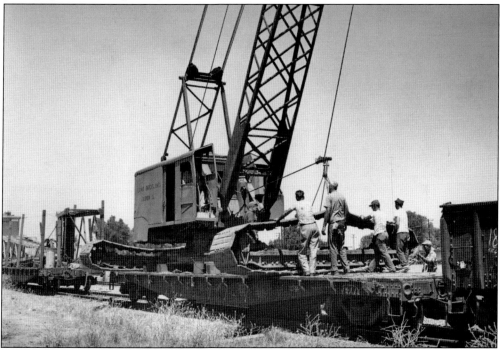

Workers unload Luhr Brothers dragline equipment for toe-drain construction in July 1957. Workers are placing track on the Manitowoc seven-yard line dredge. Delivery of dredging material to the site required four railroad cars to transport each of the dredges. The main dredger part was so large it required handling by two railroad companies. All 12 cars carrying the equipment were routed around through El Paso, Texas, in order to clear bridges and tunnels.

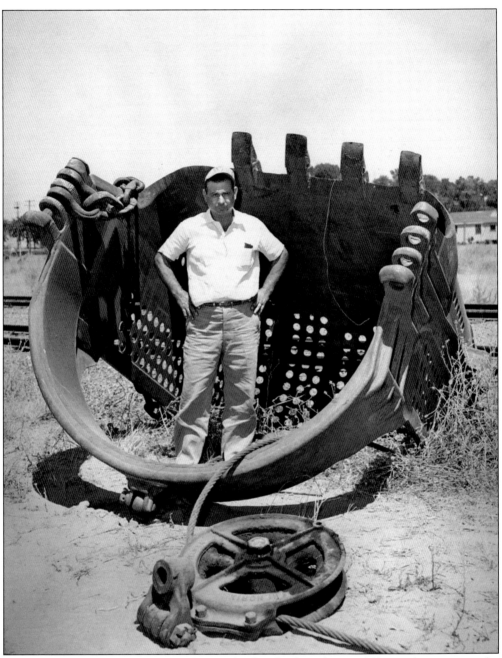

This 1957 photograph shows one of the two dragline buckets that would be used to excavate the toe drain. General superintendent Herman Hieckware is standing inside one of the seven-yard dredge buckets. The company, Luhr Brothers, is from Columbia, Illinois.

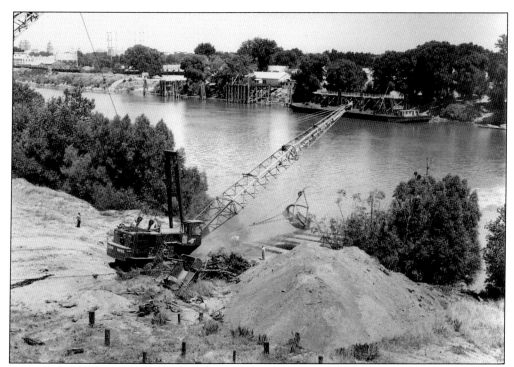

A bucket excavator creates a path to the Sacramento River and a docking site for a barge. The barge was used to transport the excavators downriver to Rio Vista to begin excavating a deepwater channel.

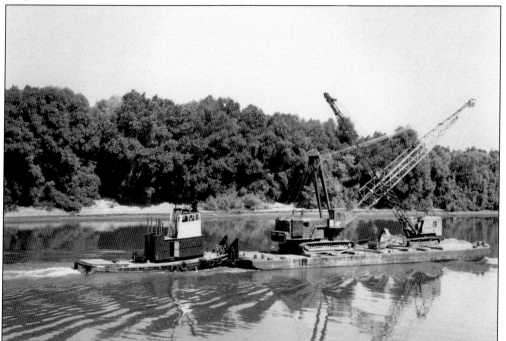

A tug pushes a barge with two-bucket dragline excavators downriver toward Rio Vista to begin deepwater channel excavation.

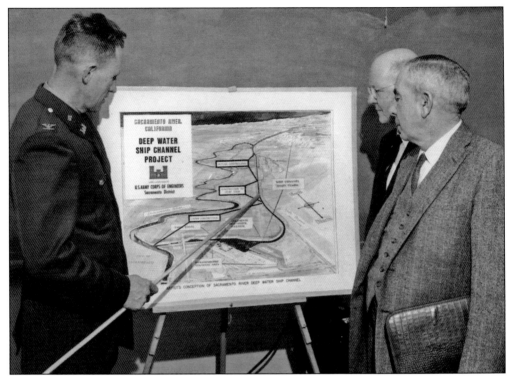

This Army Corps of Engineers display map shows the construction progress on the deepwater channel. William G. Stone is standing in the middle of the group.

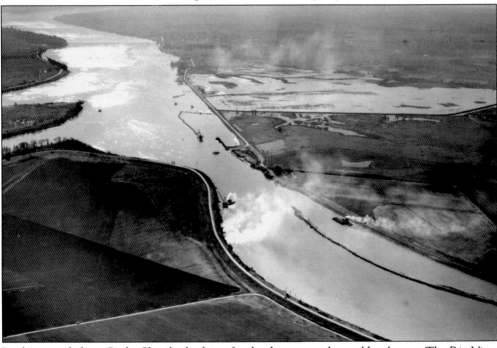

Looking south from Cache Slough, dredging for the deepwater channel has begun. The Rio Vista Bridge can be seen in the distance near the top of the photograph.

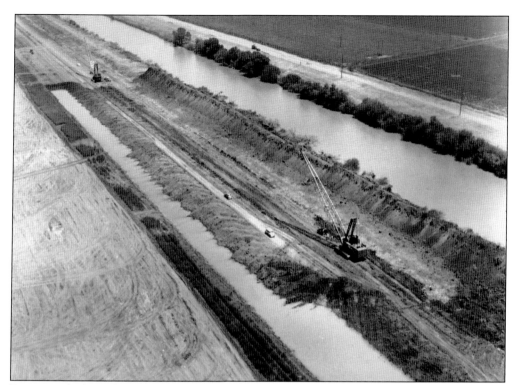

Facing north along the Yolo Bypass, two dragline bucket excavators are dredging for the toe drain. In the far right is the west cut. It would be filled in to serve as a levee for the ship channel. On the left is a section of the toe drain.

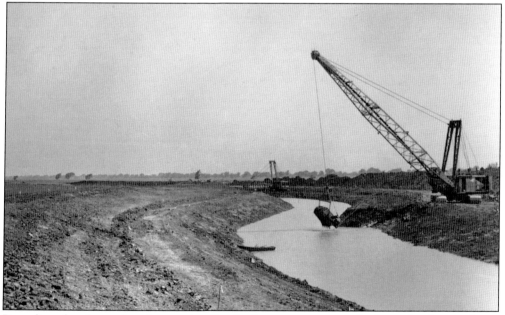

Preceding the channel work, two dragline bucket excavators are dredging for the toe drain. Located within the Yolo Bypass area, the toe drain was situated west of the ship canal and ship-channel spoil area.

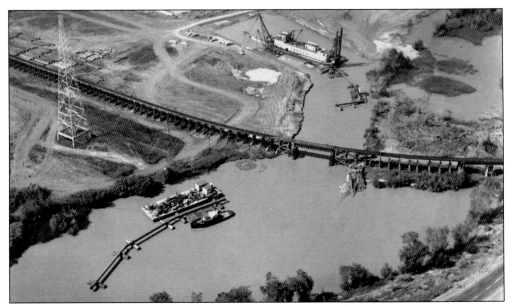

The dredge *Papoose* of Hydraulic Dredging Company is cutting the deepwater channel through the area where the Sacramento-Northern Railroad Lisbon trestle stood on September 1, 1962. The trestle at Lisbon was later burned, as it was more economical to burn than to salvage the wood timber.

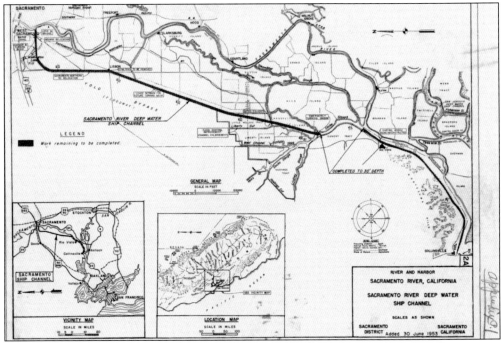

This is a 1953 map by the Army Corps of Engineers labelled "River and Harbor, Sacramento River, California- Sacramento River Deep Water Ship Channel." Showing the route of the deepwater channel, this map illustrates the area of completion along Cache Slough, near Egbert Tract, that is the site of the emergency 30-foot-deep turning basin. It would take another 10 years to complete the channel.

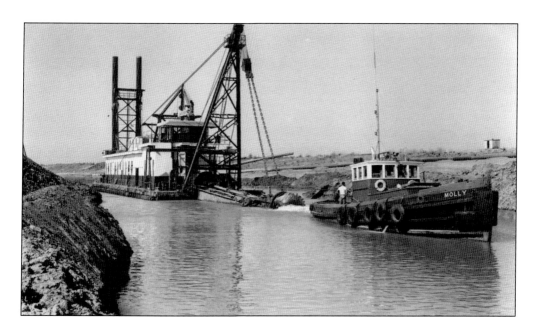

These images depict the hydraulic dredge *San Diego*. There are two types of dredges: mechanical and hydraulic. Mechanical dredges (dipper and clam shell) place the material into barges for transport to another location. Hydraulic dredges (cutterhead pipeline and self-propelled hopper) pump directly to the disposal site.

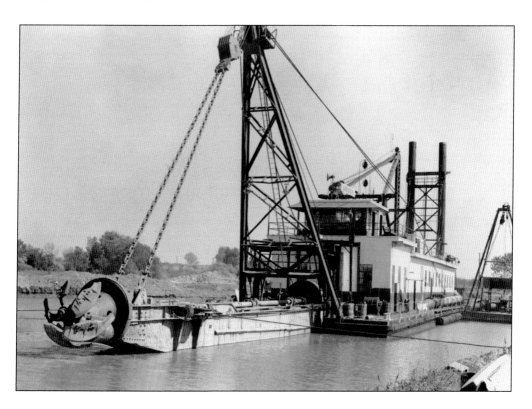

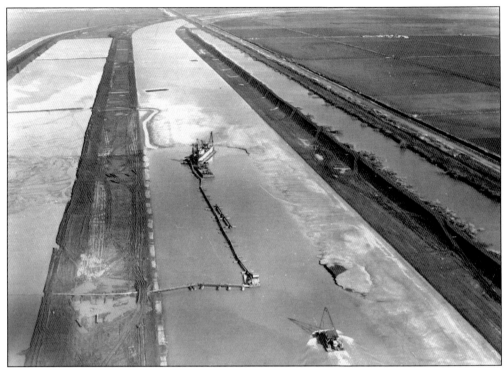

In July 1955, Pres. Dwight D. Eisenhower signed an appropriations bill that included $500,000 for continued work on the port. By 1957, an additional $2 million was approved to begin deepening the deepwater ship channel. By August 1959, the dredge *San Diego* had cut through the Yolo Bypass and had begun dredging eastward toward Lake Washington. (Courtesy Port of Sacramento.)

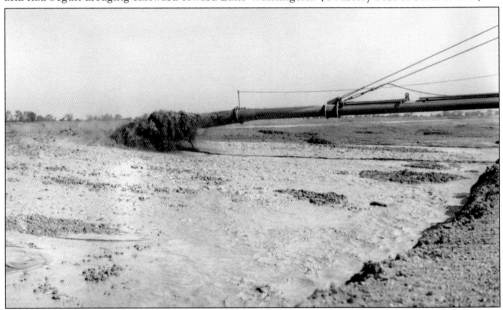

A combination of rock, mud, and water are being extracted in the Yolo Bypass while excavating the route for the deepwater channel. The canal is 43 miles long and 30 feet deep. A total of 70 million cubic yards of soil was removed to create the canal.

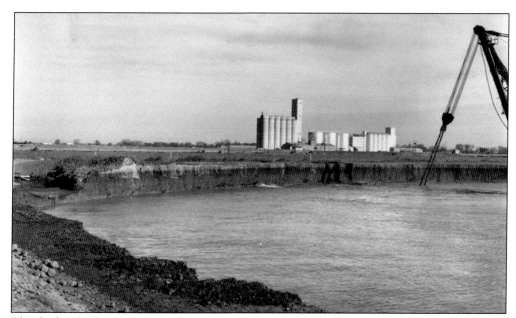

The dredge *San Diego* is pictured at noon on December 14, 1959, just nine hours before cutting through to Lake Washington at 9:14 p.m. The contractor was McCammon-Wunderlich Company and the subcontractor was the Pacific Dredging Company. (Photograph by W. G. Stone; courtesy Port of Sacramento Collection, West Sacramento Historical Society.)

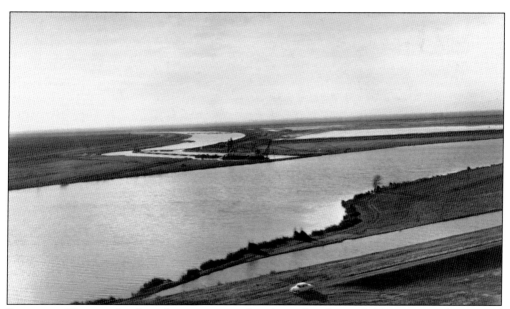

Seventy million yards of earth were removed making the channel. The average distance of discharge removal was from 1,500 to 2,000 feet from the site. In comparison, it took 80 million cubic yards of material to build Oroville Dam.

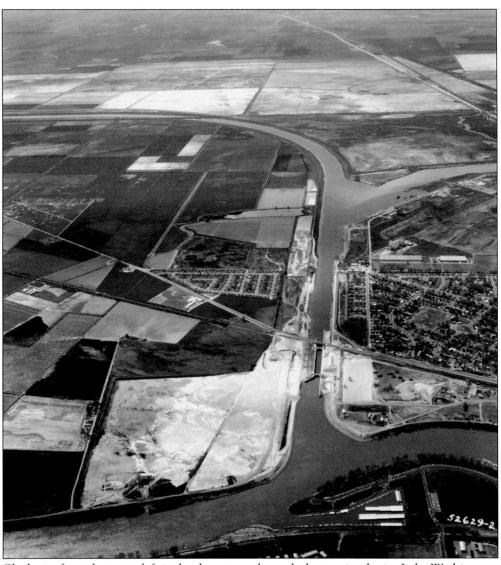

Clockwise from the upper left is the deepwater channel, the turning basin, Lake Washington, Barge Canal, the navigational locks, and the Sacramento River. Jefferson Boulevard runs left to right over the bascule bridge. Completed Miller Park in Sacramento can be seen at the bottom.

# Five

# SACRAMENTO-YOLO
# PORT DEDICATION
# AND OPERATIONS

"Sacramento Joins the Sea in '63" was the title of the port's booklet prepared for attendees at the dedication ceremonies for the Port of Sacramento on July 19 and 20, 1963. A celebration parade, headed by California governor Edmund G. Brown began at 9:30 a.m. It was composed of both civil and military marching bands and featured many dignitaries. Following the parade dedication, ceremonies were held at the port with Congressman John Moss serving as master of ceremonies. U.S. Secretary of the Interior Stewart L. Udall delivered the principal address. A telephone call was received during the keynote address from Pres. John F. Kennedy to Secretary Udall congratulating Sacramento on their new port, and it was broadcast over loudspeakers so the crowd could hear.

At a luncheon immediately following the dedication, many dignitaries were in attendance, including past and present port commissioners. Governor Brown was the principal speaker at the luncheon celebration.

On Saturday, July 20, a public open house was held featuring community organizations, private industry, and all branches of the armed forces with a host of events and displays, including a flyover, a skydiving demonstration, and musical entertainment by the 6th Army Band. A number of ocean-going ships were open for inspection, including U.S. military ships. Scores of community groups entertained celebrants throughout the day.

With the initial port development completed, there were five berths for deep-sea vessels and two slips for barges coming through the locks from the Sacramento River. Because water levels of the port's turning basin and the directly adjacent river may vary as much as 21 feet, navigation locks were required to pass vessels through and to keep floodwaters and silt from entering the turning basin and deepwater channel. In addition, 3,000 lineal feet of wharves, as well as 60-foot-wide dockside aprons with railroad tracks, provided economical cargo handling. Conveyor systems handled bulk grain and rice direct from the grain elevators to the holds of waiting vessels. Two 90,000-square-foot transit sheds served the deep-sea berths. The port provided the streets, rail facilities, water, sewer, and other utilities necessary for the terminal facilities.

The port opened with the vessel SS *Taipei Victory* on June 29, 1963. The cargo on that ship consisted of rice and logs. During the first six months, the port handled 41,457 tons of cargo, and volume grew quickly. It had reached one million tons in 1967, far outstripping early estimates of its market growth.

The Port of Sacramento has been primarily an "operating port," meaning it handles the cargoes itself, hiring personnel from union halls. In 1993, the port dealt with eight separate labor-union agreements and had a full-time staff of management, administrative, security, and some maintenance employees.

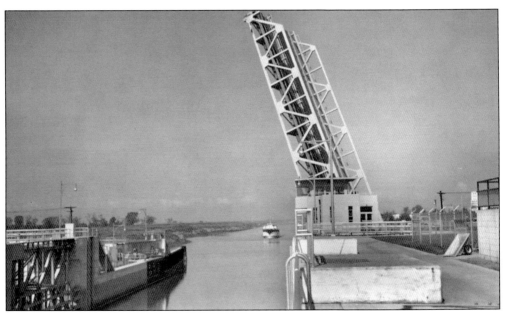

The *Harbor Prince* leaves Lake Washington Harbor and enters the lock and barge canal.

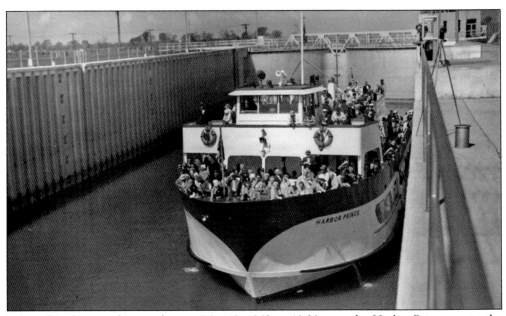

When this photograph was taken on May 12, 1963, at 10:30 a.m., the *Harbor Prince* was in the lock being lifted up 14 feet to water level of the Sacramento River. The boat was preparing for a return trip to San Francisco via the Sacramento River. (Photograph by W. G. Stone; courtesy Port of Sacramento Collection, West Sacramento Historical Society.)

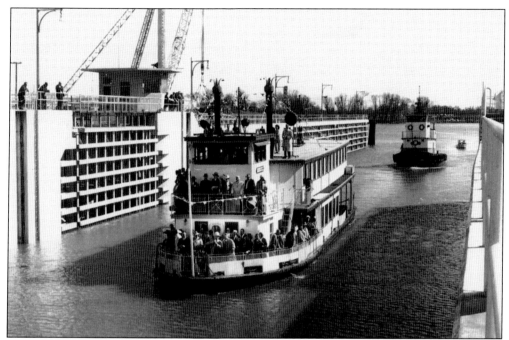

On June 29, 1963, the Port of Sacramento celebrated its completion. The three-day program of activities, which drew 75,000 attendees, included trips through the locks between the Sacramento River and the ship-turning basin. Other highlights included parades, navy vessels, and the California Maritime Academy Golden Bear cadet-training ship.

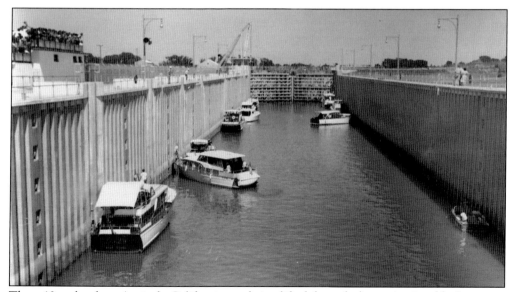

These 10 yachts from Antioch, California, are being lifted through the navigational lock to enter the Sacramento River on June 30, 1963. They were the first 10 pleasure yachts to be locked at one time. They had come up the deepwater channel and passed the *Taipei Victory*, loading rice at Berth No. 2 at the Port of Sacramento, before entering the locks and finally the Sacramento River. (Photograph by W. G. Stone; courtesy Port of Sacramento Collection, West Sacramento Historical Society.)

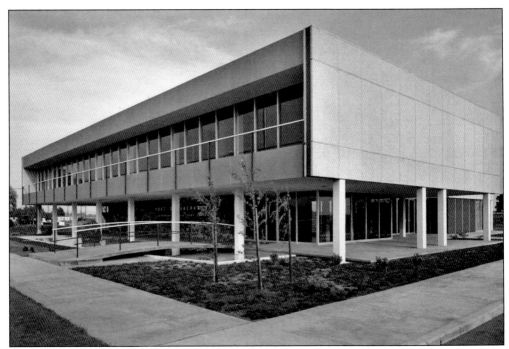

When the port district became operational in 1947 the initial staff consisted of the port director and his secretary. They were housed in partitioned area of the Sacramento County Courthouse. They later moved to the California Fruit Building at Fourth and J Streets in Sacramento. In 1961, architect Ray Fransceschi was retained to design a new building. His design, the two-story Yolo-Sacramento Port District Headquarters, known as the World Trade Center, was located in West Sacramento south of the intersection of Park and Stone Boulevards. It was occupied in January 1963, was the most modern building of its time, and was planned for future expansion. A third story was added later. When West Sacramento became a city in 1986, this building was used both for city and port administration. After vandals flooded the top floors, the interior of the building was ruined. As a result, the site was abandoned and later demolished.

The first truck arrived at the Port of Sacramento with rice cargo for the first deep-sea vessel, *Taipei Victory*, on June 20, 1963. (Photograph by W. G. Stone; courtesy Port of Sacramento Collection, West Sacramento Historical Society.)

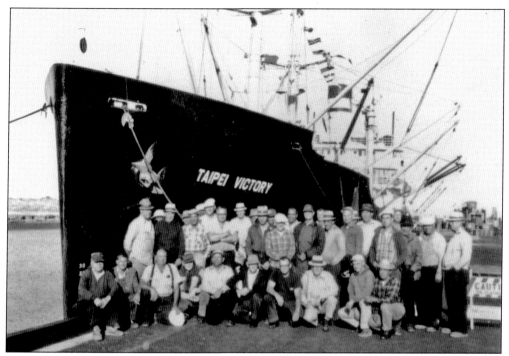

The first ship to arrive at the port for cargo was the Taiwanese vessel *Taipei Victory*. Posing at her bow are the port's first licensed longshoremen.

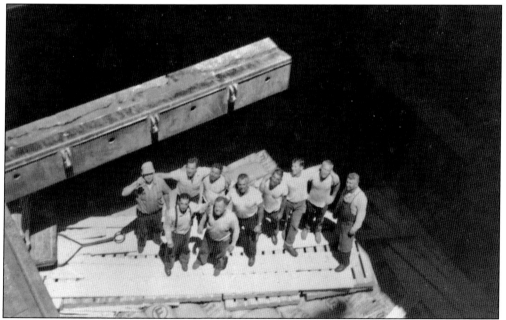

The first longshoreman gang poses in front of first ship to be loaded with Sacramento cargo, the *Taipei Victory*. Port administrators worked vigorously to obtain union labor. The port was a leading employer in the area. Working the docks and warehouses, these longshoremen are highly skilled for their tasks. Generally divided into a "gang" of 16, there were typically 17 gangs working in a 24-hour period.

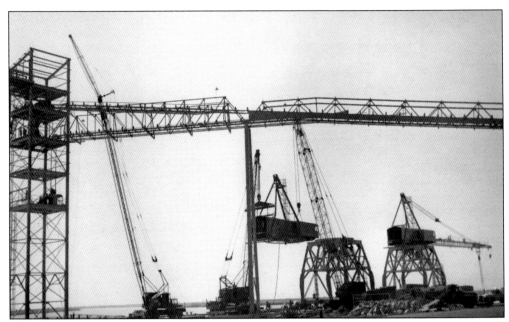

In this September 6, 1963, photograph, a grain-elevator conveyor with two large cranes is lifting the control cabin of the gantry crane into position. A completed crane is assembled on the right. Both gantry cranes served Wharves Nos. 6 and 7. (September 13, 1963.)

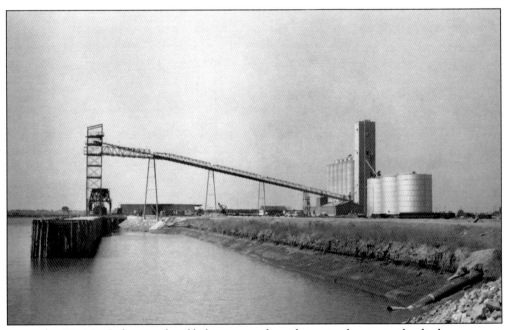

Located at Pier No. 5, the completed belt conveyor from the grain elevator to the discharge towers waits to load another ship with grain on September 6, 1963. The original storage capacity for bulk grain was 875,000 bushels. An additional 375,000 bushels was later added. The conveyor was capable of loading bulk grain at around 600 tons per hour.

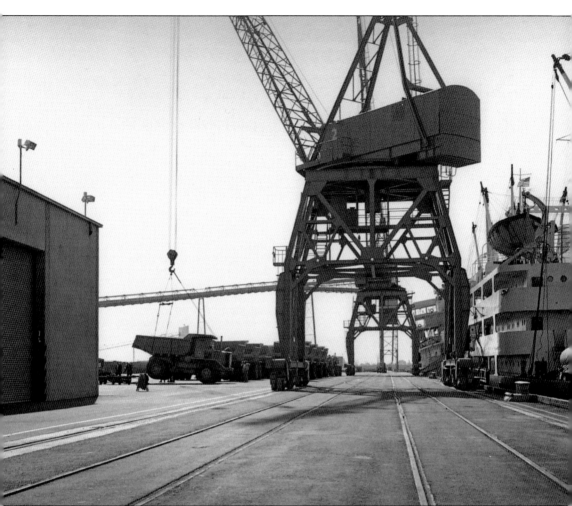

Large gantry cranes load heavy equipment. The port had two electrically driven gantry cranes. Both cranes were capable of moving along tracks between Wharf No. 6 and No. 7, the transit shed, an open paved area, and the bulk-grain loading pier. Each crane had the capacity of lifting 45 tons at 40 feet, 25 tons at 70 feet, and 7 tons at 135 feet. Currently the port has no permanent cranes.

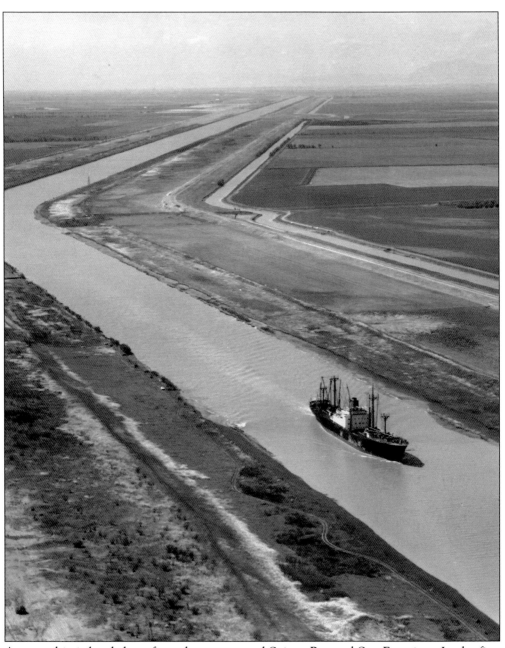

A cargo ship is headed out from the port toward Suisun Bay and San Francisco. In the first quarter of 1980, about one million tons of cargo was shipped. During 43 years of operation, the port shipped tons of almonds, canned goods, dairy products, soybeans, bagged rice, safflower seed, wood chips, newsprint, sand, aggregate and decorative rocks, logs, lumber, palletized kaolin clay, bulk wheat, brown and rough rice, bagged and bulk fertilizer, and wheat and project cargo to other parts of the world.

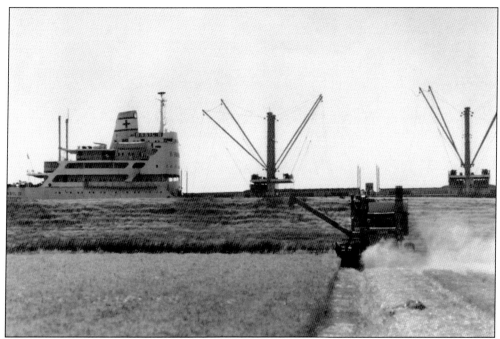

This is a strange sight indeed. As a ship heads up the Sacramento River Deep Water Ship Channel toward the port, a farmer is harvesting wheat in the Southport area of West Sacramento around 1965. Today residential housing and commercial warehouses have replaced agriculture.

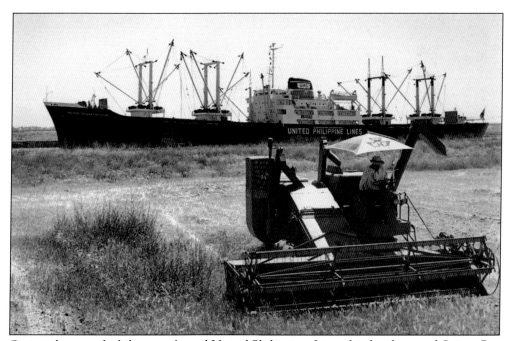

Grain is harvested while an outbound United Philippines Lines ship heads toward Suisun Bay and San Francisco.

The paved area was ideal for cargoes requiring outside storage. Logs are loaded for shipment, hauled in, and sorted and stacked (decked) in preparation for shipment. This open area is adjacent to open Wharf No. 6, where the gantry cranes could load the logs onto the ship.

This is the port's automatic truck dumper. Commodities can be received in a bottom dump or tailgate dump trucks and go to storage or direct to vessel. Other features of the port include flat storage for 125,000 tons of cargo, bagger and warehouse facilities for 50- to 80-pound sacks of bulk, a rail yard for 200 cars, a 50-acre log yard, two 9,500-ton-capacity dolmar buildings, a 30,000-ton-storage-capacity (1.25 million-bushel-capacity) building, and 380 acres of zoned property for industrial, office space, and waterfront property.

This ship was especially built for the Sacramento-Yolo Port harbor and deepwater channel to transport larger amounts of bulk rice. This photograph shows the launching of the Japanese vessel *Honshu Mar*. The vessel could carry 14,000 tons of wood chips. The hull was in the shape of a bathtub, allowing a maximum of storage capacity for shipment. This photograph was taken June 7, 1967.

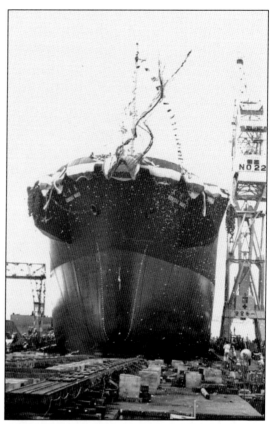

These officials, from left to right, are the following: (first row) assistant manager of the lumber department M. Araki, port director Melvin Shore, executive managing director A. Gunji, and manager of the lumber department K. Kogure; (second row) Ito and S. Kinsoshito of the lumber department. These men are signing a Japanese seven-year contract for bulk wood chips. The Port of Sacramento was the only port to export wood chips. An additional 10-year contract was approved with Mitsui for 1.2 tons of wood chips that would be manufactured into writing and kraft packing paper.

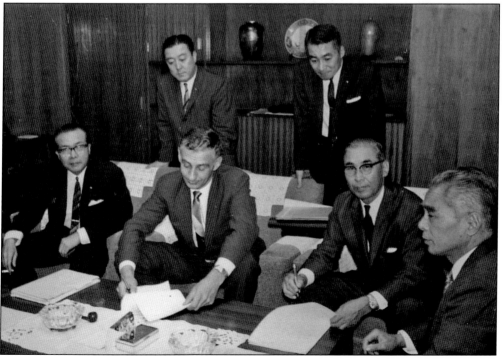

Loading bags of grain is demanding work for the longshoreman. This was the earlier method of loading cargo. Today, replacing the use of pallets, the cargo is placed into 18 thirty-kilogram bags with hoisting straps. To meet the large tonnage of grain export, some seagoing vessels, such as the Honshu Mar on page 101, were designed to accept bulk grain. It was much faster and easier to load, and required little assistance in loading compared with bagging and loading by swing.

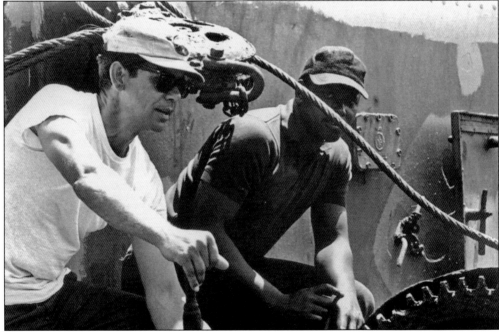

Skilled longshoremen are required to operate various equipment, such as hoists, forklifts, and cranes, to lift stacked grain bags and load logs and heavy equipment. During the Vietnam War, airplanes from McClellan Airbase were shipped to San Francisco from the Port of Sacramento.

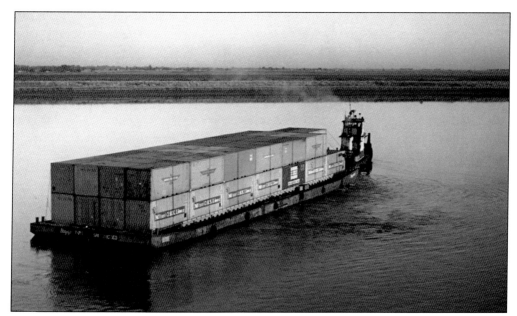

This container barge and tugboat head toward the deepwater channel to the San Francisco–area container terminals. These barges were equipped to handle 20- and 40-foot containers. In the later 1960s, the port began this new container-shipping service to and from the San Francisco Bay Area.

The Port of Sacramento experimented in container shipping through the use of barges. The first loaded container vessel delivered to the San Francisco Bay terminals was by the barge *Pioneer*. The cargo consisted of fruit cocktail produced by the Sacramento Foods Division of Borden, Inc. It was loaded on seagoing vessels that were too large to use for the deepwater channel.

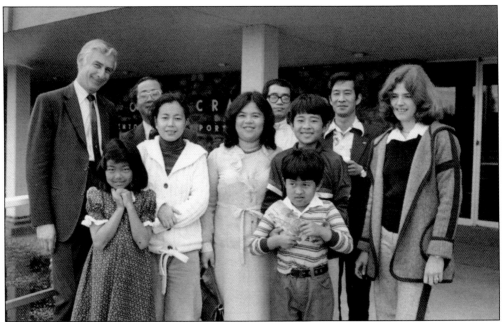

Port director Melvin Shore, left, is pictured with Japanese students and family outside port headquarters in 1978. (Courtesy Port of Sacramento.)

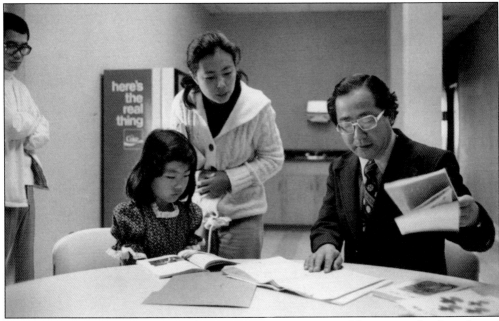

Japanese youngsters stay current in their native tongue at a special language school conducted Saturdays at the World Trade Center in West Sacramento. Prof. Shotaro F. Hayashigatani, director of the Japanese-American language program from California State University, Sacramento, is seated at right. The course was offered at the port because port director Melvin Shore found the need for it in discussion with businessmen in Tokyo. Parents scheduled for assignments in Sacramento expressed concern that their children would lose their Japanese language capability. (Courtesy Port of Sacramento.)

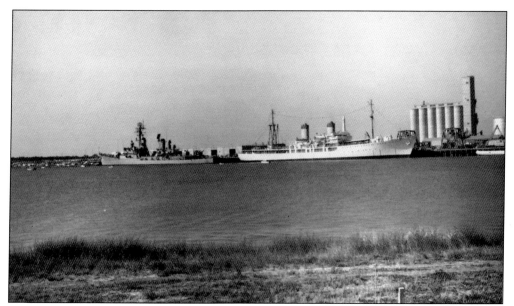

While this photograph is from the opening-day celebration, it shows the various types of vessels that docked at the Port of Sacramento. Here the USS *Lynds McComick* DDG-8 and the *California Bear*, a California Maritime Academy Training Ship, are berthed at the port.

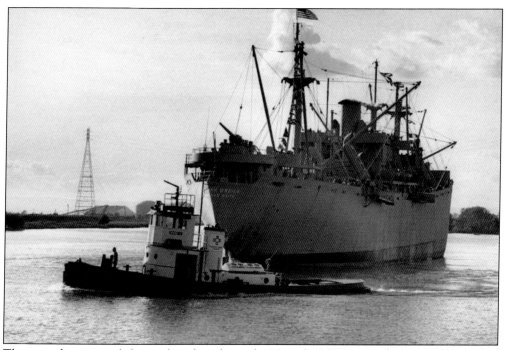

The port also received ships other than for trade. Here the USS *Jeremiah O'Brien* liberty ship makes a visit. This vessel, the last of the operating liberty ships, is based in San Francisco and makes several trips a year up through the delta. Other ships to the port have included cruise ships, U.S. Navy vessels, the Maritime Academy ship *Golden Bear*, and historical sailing ships.

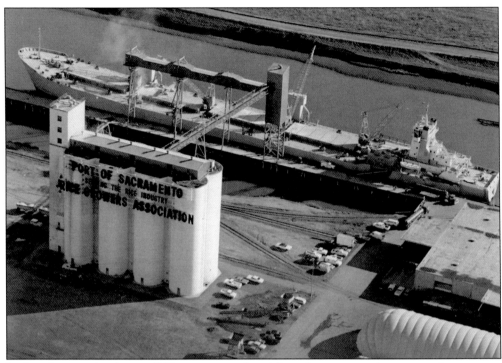

In this photograph taken in 1970, rice is transferred from the port rice elevator via the conveyor system to the ship *Valerie F*, the integrated tug/barge unit at Pier No. 1. The *Valerie F* provided regular service to San Juan, Puerto Rico, and the East Coast. Rice cargo could be either bulk white, brown and rough, or paddy rice. The storage capacity of the facility is 23,000 tons. The berth for ships is 600 feet in length with a depth of 30 feet. Rice was delivered to the elevator by rail service. The huge nylon-vinyl air-supported structure at lower right is for backup cargo storage. It is no longer there.

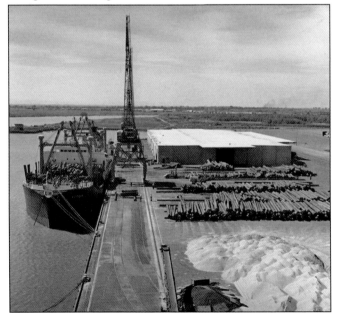

One of the largest cargos shipped from the port involved logs. Here, at Wharf No. 7, a ship is being loaded with logs by a gantry crane. In the first six years, five million tons of cargo passed through the port. The loading dockside aprons at the port are 60 feet wide. This width was used in marketing to show how the port was uncluttered and had open loading areas. Shed No. 7, at right, was used for general cargo, bagged rice, newsprint, or fertilizer. The small building structure left of the ship is the site of the Lake Washington Sailing Club and River City Rowing Club.

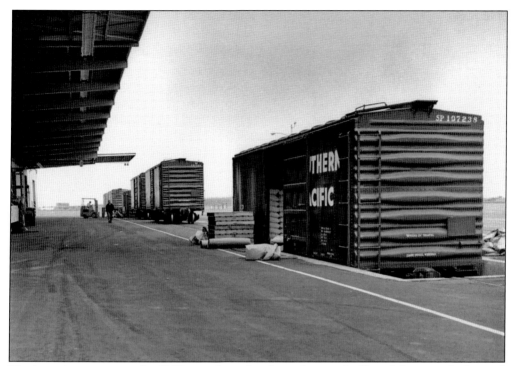

The latest innovation in the 1960s was the railroad-car elevator. It allowed the car to be lowered so that the entry door was at ground level. This eliminated the use of loading docks and platforms. There were two elevators at each transit shed.

With rail cars lowered to ground level, loading and unloading cargo was made easy, fast, and safe compared with the most conventional platform or dock method.

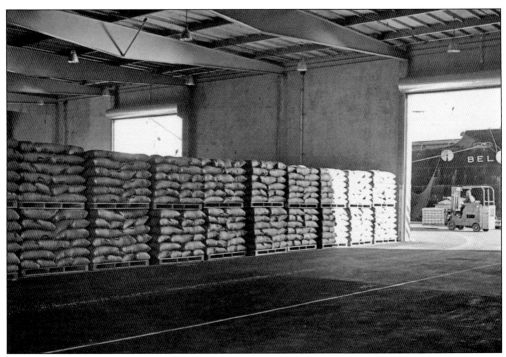

The port warehouse has a 336,000-square-foot capacity for bulk flat and general cargo, and a domed building with a bottom reclaim. Wharf No. 2 and Shed No. 7 stored general cargo, bagged rice, newsprint, and break bulk (maritime terminology for loose cargo stacked on other cargo, such as cartons).

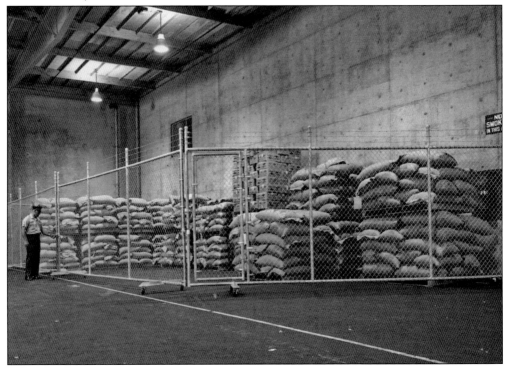

One of the earliest contracts was for the transportation of the Japanese car company, Subaru, of Northern California. After arriving at the port aboard the M/V *Prosperity*, the automobiles were transported to local distributors in Northern California, Southern Oregon, or Nevada.

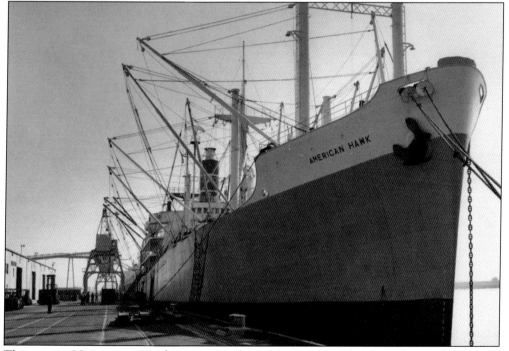

The steamer SS *American Hawk* awaits cargo bound for overseas. This ship is known for carrying military cargo to Asia during the Vietnam War era. On October 3, 1967, the *American Hawk* delivered Advanced Satellite Products Branch supplies to Saigon.

Operating tandem forklifts, dockworkers load a ship with lumber for shipment near the Wharf No. 6 open apron. Ships were capable for loading both bulk grain and lumber/logs at the same time.

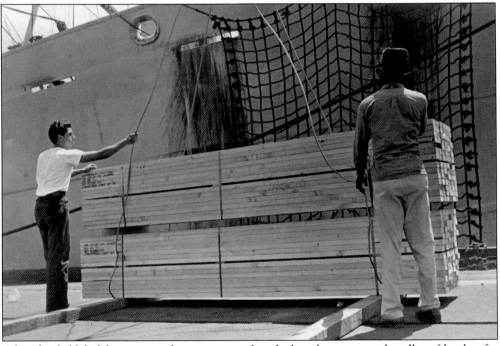

After the forklift delivers cargo from storage, other dockworkers prepare bundles of lumber for hoisting onto a freighter. Historically, overall tonnage for shipping dropped from 1.2 million short tons in 1992 to 779,000 short tons in 2004.

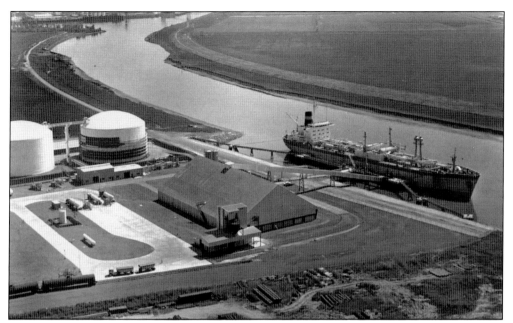

Before entering into the port and turning basin, vessels transporting liquid fertilizers dock at the Collier Carbon and Chemical's Dockside Facility to discharge their cargo. Located on the ship channel, the 16-acre site provided distribution of ammonia-based fertilizer products. The facility was later owned by Union Carbide. Ownership is now under Agrium, Inc.

Tugboats from the Sacramento Tugboat Company were kept busy towing or pushing barges and directing large vessels to dockside berthing.

Towing and barge carriers offered a variety of services from push boats to providing ship assistance and tenders for marine construction. By 1999, the tug service was provided by Brusco Tug and Barge, a Columbia River, Washington state–based company. With a fleet of 29 craft, 11 worked at Sacramento. Ninety percent of ocean-going vessels required a tug service.

Ship crane operators hover over cargo being loaded or unloaded. Using their own gear, vessels can swing special spreaders hoisting 18 thirty-kilogram bags at a time or several 40-foot containers from dockside into their holds for shipment. A specially built 459-foot Norwegian newsprint carrier was equipped with a unique vacuum roll capable of loading 200 tons of paper per hour.

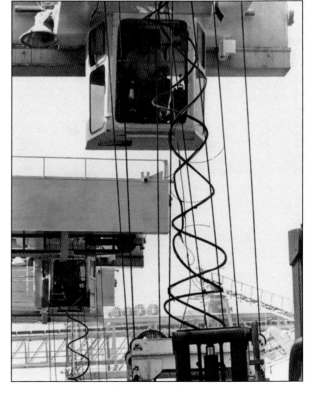

Through the years, the port employed many highly skilled laborers. The International Longshore and Warehouse Union (ILWU Local 17) provided a qualified workforce in handling the loading and unloading of vessels. In this photograph, a longshoreman guides a large hook with a safety lock from one of two gantry cranes.

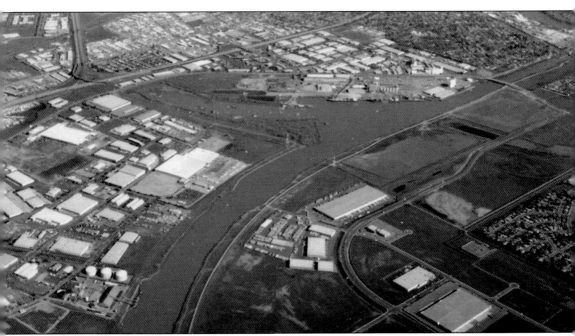

Here is an aerial photograph of port facilities in 1999. Since they were established, both commercial and residential growth near this area has escalated. During poor trade years, the port was forced to sell off various future-expansion property sites. The port and its turning basin remain operational since the City of West Sacramento took control. The Lake Washington Sailing Club still uses the lake and turning basin for recreational and competition sailing, although motorized boating is limited. The University of Davis Rowing Club and other local rowing teams use the harbor and barge canal for competitive rowing. In 1996, a new bridge was built between the harbor and bascule bridge connecting Industrial Boulevard to Jefferson Boulevard and the new Southport area of warehouses and residential developments.

# *Six*

# THE PORT TODAY AND PHOTO OPPORTUNITIES

Recently governance and management of the port has changed drastically. The City of West Sacramento officially took control in June 2006. There are now five sponsoring agencies involved in the master plan called the "Maritime Demand Analysis and Master Use Plan." They include the Port of Sacramento, the City of West Sacramento (project management), the City of Sacramento, and Yolo and Sacramento Counties. Their goal is to define the port's future and to do the following: provide detailed assessment of the market, competitiveness, and types of cargo; characterize the port's economic significance; identify future facility and land requirements; evaluate potential non-maritime activities; and identify traffic and air quality

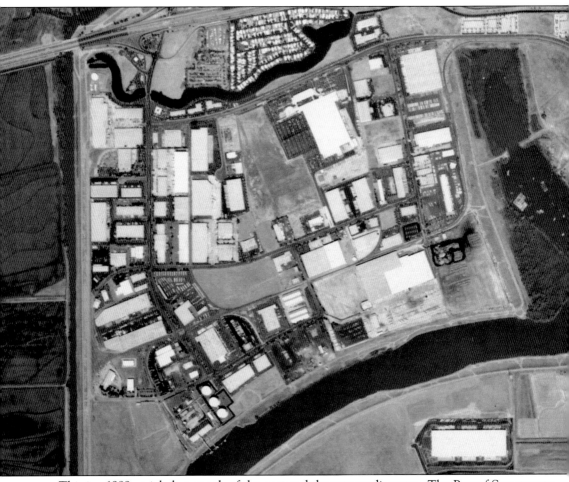

This is a 1999 aerial photograph of the port and the surrounding area. The Port of Sacramento incorporates nearly 3,000 acres of waterfront land along the ship channel to the Sacramento Delta. Today the City of West Sacramento is managing the facility under the mitigation bank

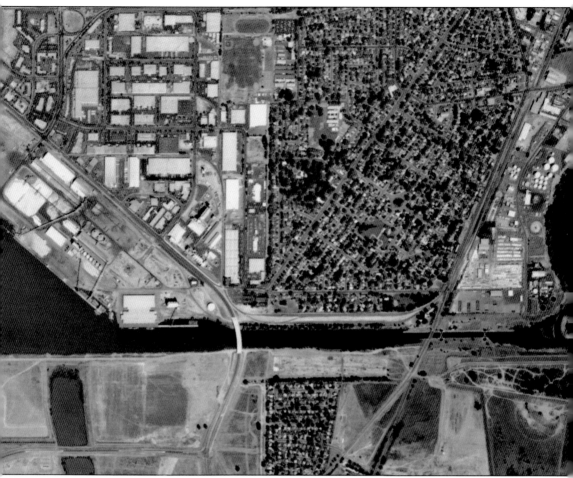

concept, combining upland habitat, riparian habitat, and wetlands. Divided into two sectors, North Port Property and South Port Property, the city is offering over 200 acres for development within the enterprise and free-trade zone.

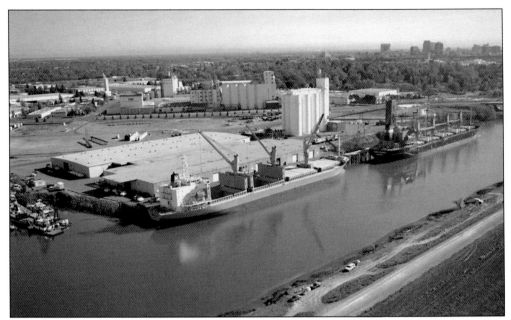

This 2005 photograph shows a busy port. It continues to offer five berths, each 600 feet long, to provide services for more than 50 truck companies, and to house a 200-railcar terminal area. Also at the facilities are storage for bulk rice and bulk grain, bagged commodities, dry-bulk warehousing, three large transit sheds, and paved open storage areas.

In this 2003 photograph, members of the West Sacramento Historical Society enjoy the annual July barbecue at Lake Washington near the Port Turning Basin with the Lake Washington Sailing and River City Rowing clubs. This portion of the Lake and Port Turning Basin still offers a rural atmosphere and provides water-sport recreation, as it has since 1913. Each year, the City of West Sacramento Sponsors a photograph contest called "15 Days in May." The port is very photogenic, so many photographs of it are submitted each year. This last section of the book is devoted to recent photographs of the port. (Courtesy West Sacramento Historical Society.)

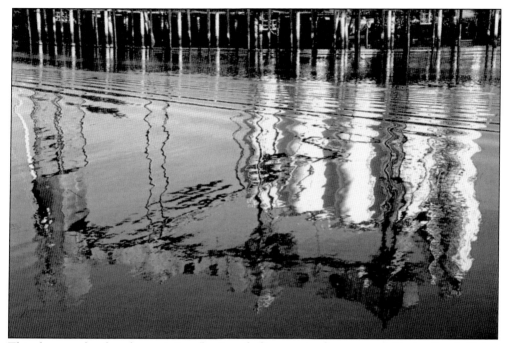

This photographer found an artistic reflection of pilings, grain elevators, and ship-loading facilities. (Courtesy City of West Sacramento and Alice Courter.)

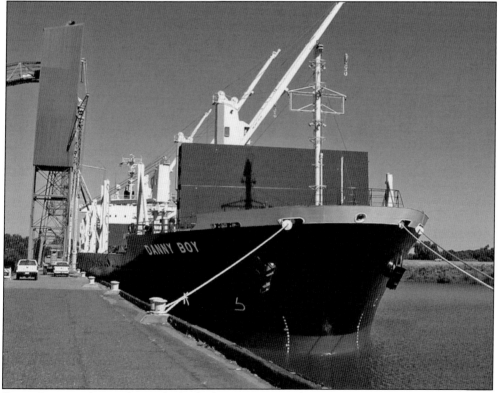

*Danny Boy* is tied up and rests dockside. (Courtesy City of West Sacramento.)

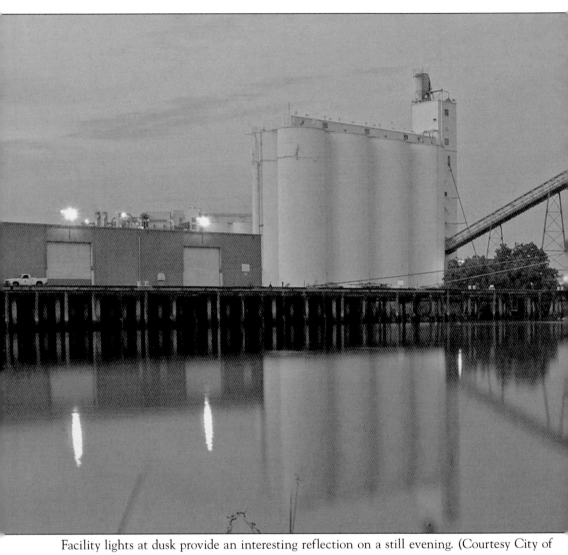

Facility lights at dusk provide an interesting reflection on a still evening. (Courtesy City of

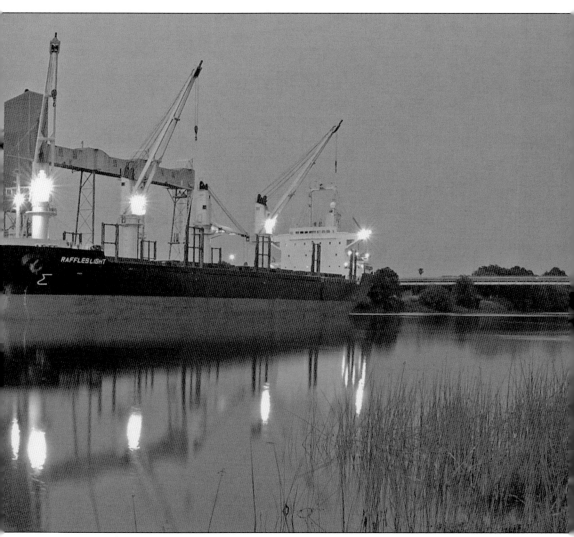

West Sacramento.)

A fisherman makes recreational use of the deepwater channel and turning basin. (Courtesy City of West Sacramento and Alvin Turilla.)

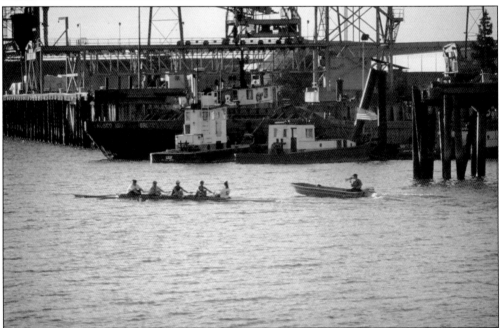

A rowing crew is coached from a motorboat as it passes in front of the working docks at the port. (Courtesy City of West Sacramento and Kenny Leasch.)

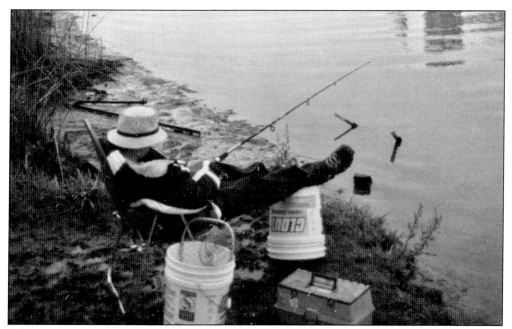

Fishing continues to be a favorite recreational activity along the river and port area, as demonstrated here in 2000. (Courtesy City of West Sacramento and Gary Clements.)

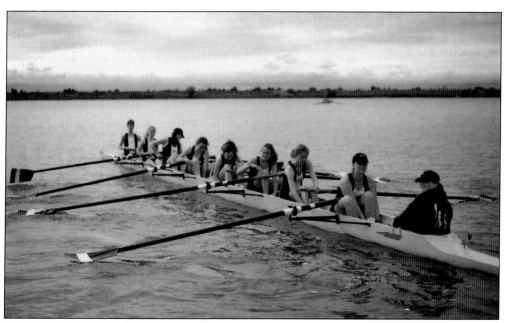

Featured in this 2000 photograph is the River City Rowing Club on Lake Washington near the ship-turning basin. (Courtesy City of West Sacramento and Andrea D. Morgan.)

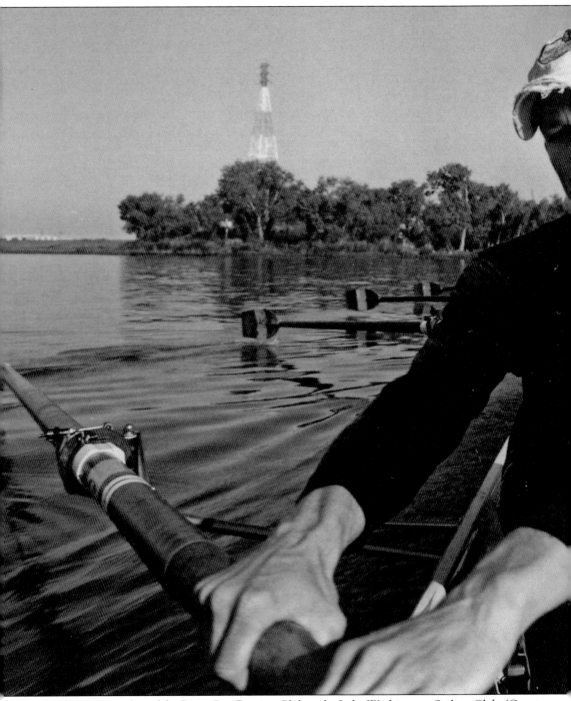

This is a member of the River City Rowing Club at the Lake Washington Sailing Club. (Courtesy

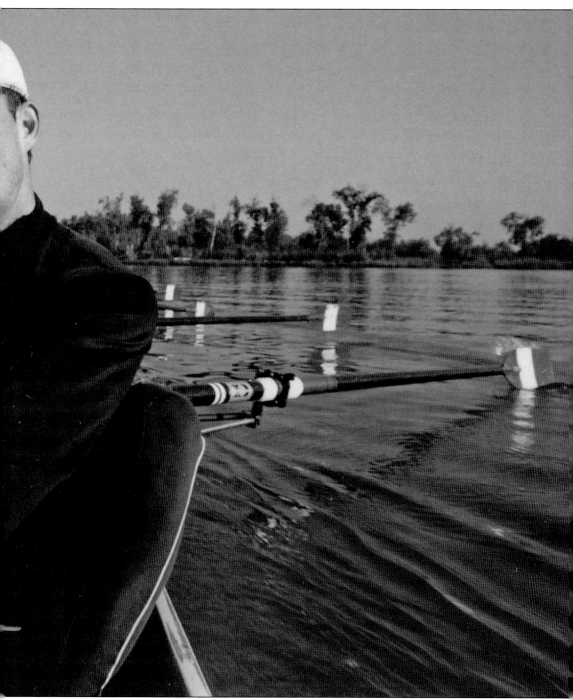

City of West Sacramento and Wesley Sherlock.)

# PAST PORT COMMISSIONERS AND PORT DIRECTORS

## Port Commissioners

| NAME | PROFESSION | START TERM | CHAIR TERM |
| --- | --- | --- | --- |
| Earl Withycombe* | State official | 05/19/1947 | 05/19/1947–12/31/1952 |
| Roy Deary** | Bottling company owner | 05/08/1947 | |
| Frank Lawrence** | Labor leader | 05/08/1947 | 01/01/1953–05/07/1956 |
| Walton Holmes*** | Banker | 04/28/1957 | |
| Ivory Rodda*** | Investment Advisor | 05/19/1947 | 05/26/1976–05/25/1980 |
| Donald Mitchell* | Trucking company official | 01/01/1953 | |
| Alan Merkeley* | Farmer/county official | 03/15/1955 | |
| Robinson Crowell*** | Advertising official | 04/19/1955 | 05/08/1956–04/27/1966 |
| Mike Elorduy** | Labor leader | 05/08/1956 | |
| Wayne Smythe* | Pharmacist | 11/09/1957 | |
| Curzon Kay* | Sugar company official | 05/19/1961 | 05/26/1966–05/25/1970 |
| Tom Richards** | Cannery official | 09/01/1963 | |
| G. Wayne O'Brien** | Oil company official | 01/14/1965 | 05/26/1970–05/25/1974 |
| Richard Crow*** | Attorney | 05/09/1966 | 05/26/1974–05/25/1976 |
| Edwin Park** | Labor leader | 04/25/1974 | 05/17/1982–06/12/1984 |
| Thomas Campbell*** | County official | 09/04/1976 | 05/26/1980–05/16/1982 |
| Willie Bell*** | Architect | 04/01/1981 | 06/13/1984–06/12/1986 |
| James Cameron* | Attorney | 03/16/1982 | 06/13/1986– |
| Edward Lammerding*** | Banker | 05/17/1982 | |
| Virginia Mueller* | Attorney | 05/11/1983 | |
| Alphonso Gonzalez* | Attorney | 06/26/1984 | |

*Appointed by Yolo Board of Supervisors
**Appointed by Sacramento City Council
***Appointed by Sacramento County Board of Supervisors

# Current Port Commission

| COMMISSIONERS | TERM DATES |
|---|---|
| Mike McGowan, Chair* | 02/22/1995–02/22/2007 |
| Illa Collin, Vice Chair** | 08/-1/2001–06/22/2009 |
| Christopher Cabaldon, Commissioner*** | 03/10/2004–03/10/2008 |
| Carolyn C. Pierson, Commissioner*** | 12/15/2004–12/31/2007 |
| Wes Beers, Commissioner*** | 01/18/2006–01/17/2010 |
| Oscar Villegas, Commissioner*** | 01/18/2006–01/17/2010 |

*Yolo County Supervisor
**Sacramento City Council
***City of West Sacramento Council

# List of Port Directors

| DIRECTORS | TERM DATES |
|---|---|
| William G. Stone | 1947–1963 |
| Melvin Shore | 1963–1986 |
| Dennis Clark | 1986–1990 |
| Mike Vernon | 1990–1995 |
| John Sulpizio | 1995–2006 |

# DISCOVER THOUSANDS OF LOCAL HISTORY BOOKS FEATURING MILLIONS OF VINTAGE IMAGES

Arcadia Publishing, the leading local history publisher in the United States, is committed to making history accessible and meaningful through publishing books that celebrate and preserve the heritage of America's people and places.

Find more books like this at
## www.arcadiapublishing.com

Search for your hometown history, your old stomping grounds, and even your favorite sports team.

Consistent with our mission to preserve history on a local level, this book was printed in South Carolina on American-made paper and manufactured entirely in the United States. Products carrying the accredited Forest Stewardship Council (FSC) label are printed on 100 percent FSC-certified paper.

MADE IN THE USA